IMAGES OF

Windsor & Eton

Michael Stiles

NONSUCH

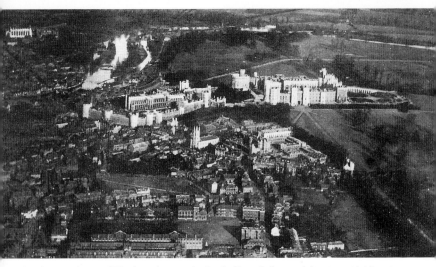

Another aerial view of Windsor, showing the Castle, Eton College and the river with Victoria Barracks and Batchelors Acre in the foreground, c. 1930.

First published 1998
This new pocket edition 2005
Images unchanged from first edition

Nonsuch Publishing Limited
The Mill, Brimscombe Port,
Stroud, Gloucestershire, GL5 2QG
www.nonsuch-publishing.com

British Library Cataloguing in Publication Data.
A catalogue record for this book is available from the British Library.

ISBN 1-84588-188-5

Typesetting and origination by Nonsuch Publishing Limited
Printed in Great Britain by Oaklands Book Services Limited

Windsor & Eton

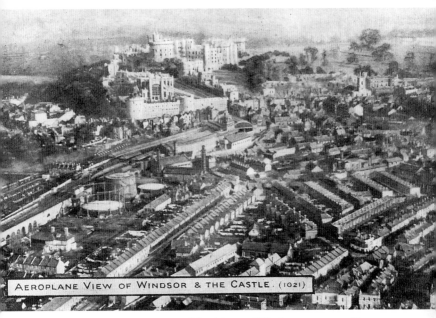

AEROPLANE VIEW of WINDSOR & THE CASTLE. (1021)

An aerial view of Windsor from a postcard dated August 1922, showing streets and houses now demolished and replaced by Ward Royal. The gasworks, gas-holders and the coal-yard have been turned into a coach-park.

Contents

Introduction

Windsor in the 1830s was a small market town greatly distinguished by the presence of the Court and Castle, the chief Royal residence. When the new Great Western Railway London to Bristol railway was announced, there was total disagreement amongst local opinion over the route of the proposed branch line to Windsor. Consequently, although the Great Western Railway Bill received Government approval in 1835, it was another fourteen years before the branch line to Windsor was constructed. The South Western Railway also pressed its claim for a line that would link Windsor to Waterloo, further into London. Paddington, the GWR terminus, was dismissed as a mere suburb. The Crown's attitude to the railway was crucial, since any service to Windsor had to pass through its Great Estates surrounding the town. It objected to the loss of privacy and the potential loss of view from the Castle, as well as the undoubted noise and smoke that the steam locomotives would bring. The Crown's opposition was withdrawn in the late 1840s when the G.W.R. agreed to pay £25,000 towards the Castle's improvements and to build a new station complete with accommodation for Her Majesty. The South Western Railway came to a similar financial agreement to traverse the Home Park and build its own station at Riverside. Eton College's opposition to the Windsor Railway, also determined and long lasting, was able to draw on powerful support, as many leading politicians of the day had been educated there. Eton was eventually appeased by elaborate plans to run the GWR line over Brocas Meadows on a viaduct, specially designed by Isambard Kingdom Brunel, high enough for the Eton boys to pass beneath it in their top hats without stooping.

Rivalry between the two companies to get to Windsor first was intense. The race was won by the GWR and on 8 October 1849, the first train left Windsor for the six minute journey to Slough. Royal patronage soon followed and for nearly fifty years the elegant timber-built station, designed by Brunel, continued to serve the Court and town. In 1897 the GWR obtained permission to build a new station to commemorate the Queen's Golden Jubilee. The present imposing brick, steel and glass structure is the result.

The social life of Windsor was influenced by the presence of the Royal Family. The town also had a rich social life of its own, including several amateur dramatic groups and the Royal Albert Institute which provided lectures, sports and social activities for its members. The breweries were the main employers in Victorian Windsor but goldsmiths and jewellers flourished due to the presence of the Court and military in the town. In contrast, the poor of Windsor had a very hard life in a town notorious for its slums. Victorian poverty was alleviated in the second half of the nineteenth century by the passing of laws to forbid child labour and by a building programme of sewers, hospitals and schools. By 1900 the life of Windsor had changed dramatically: an efficient police force and fire brigade now protected the town and electricity, running water, street lighting and the railways had arrived. It was only in the Castle that things had altered very little since 1837; in 1900 the Castle was still lit by gas at Victoria's insistence.

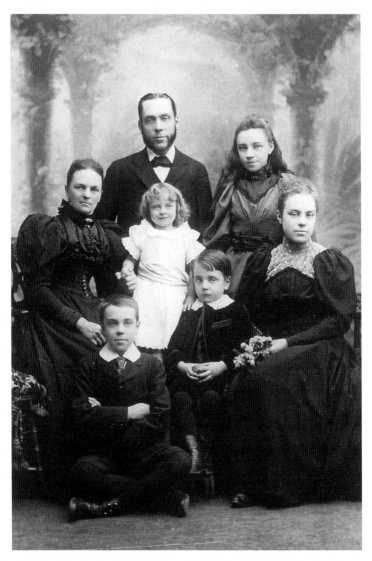

Portrait of the Stiles family, c. 1900. William and Elizabeth, with their children Miriam, Phoebe, Bernard (the author's grandfather), William junior, and Kathleen. All of the postcards and photographs reproduced in this book are from my own collection and from the Stiles family connections.

One

Windsor Castle

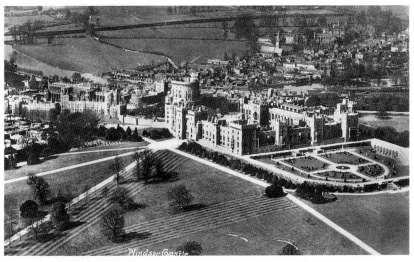

Windsor Castle is mentioned in the Domesday Book of 1084, as occupying half a hide of land in the Parish of Clewer. Half a hide might mean anything between twenty and sixty acres; the Castle at present covers some thirteen acres. Windsor Castle is the largest surviving castle in Europe and probably the most imposing royal castle in existence anywhere. A royal residence, although little more than a hunting lodge, stood two miles away at Old Windsor in Saxon times. But it was William the Conquerer in the eleventh century who chose its hilly site overlooking the Thames. It was built as a wooden fortress, but in the late twelfth century, Henry II began to rebuild the Castle in stone, from which period the outer walls of the Upper Ward and lower half of the Round Tower survive.

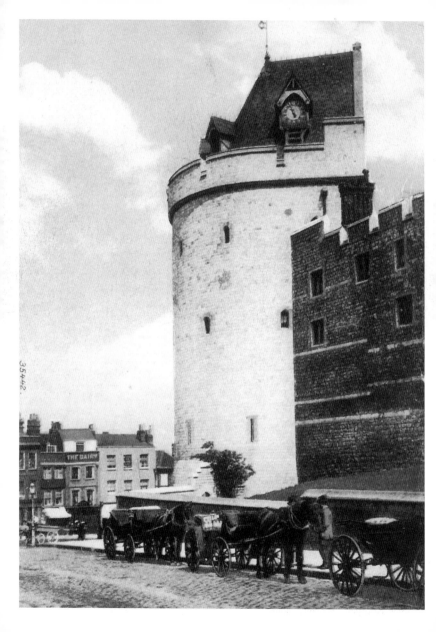

THE DAIRY

35442.

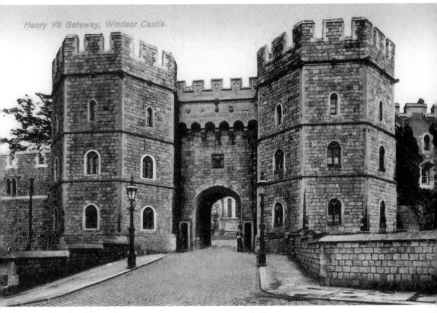

King Henry VIII's Gateway is sited at the lowest extremity, farthest from the Royal Apartments. It was built here so that, should it fall to attackers, any further progress would require a stern uphill fight. The Gateway was rebuilt by Henry VIII in about 1510. In the earlier days of his reign, largely because of the hunting to be had in the Great Park, Windsor was much favoured by the bluff sporting monarch. And it was to Windsor that he brought his succession of unhappy wives. The printers of this postcard have made an error in attributing the Gateway to Henry VII.

Opposite: The Curfew Tower was built in 1227 and contains some of the earliest untouched masonry in the Castle. The exterior is severely uniform, having been re-faced in 1863, by the French architect Salvin, who added a sharply pointed roof in the style of his native castles to minimise damage from rain. The tower contains relics of an old gaol with a pair of stocks in good working order. The interior walls were built of chalk, the only available material locally, and one of the old dungeons contains the beginnings of a tunnel through which a prisoner hoped to escape only to be defeated by the thickness of the masonry. Under the tower there is also a Sally Port, one of three in the Castle intended to form a secret entrance and exit in time of seige. The upper part of the tower contains the Castle bells, brought there in 1478 and erected on massive timbers still nobly doing their work. A flight of steep uneven stairs leads up to the fascinating clock made in 1689 by John Davis, a native of Windsor. The clock, restored but largely original, is of great ingenuity, solid workmanship and admirable precision. It plays St David's Psalm, rings some merry peals every three hours and then goes through it all twice again for good measure.

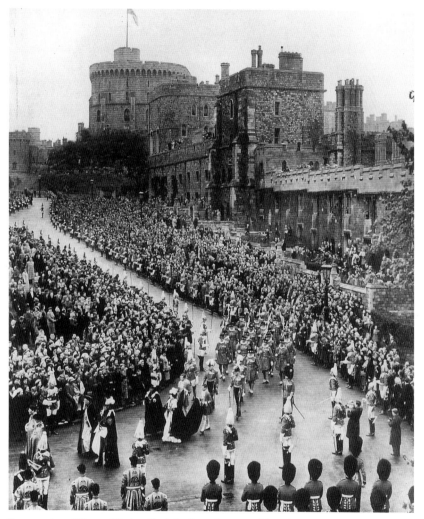

For more than 600 years Windsor Castle has been the scene of the colourful pageantry of the Order of the Garter ceremonial. Here the King and Queen are seen in their Garter Robes, walking in procession down the hill towards St George's Chapel for the impressive ceremony on 9 May 1951.

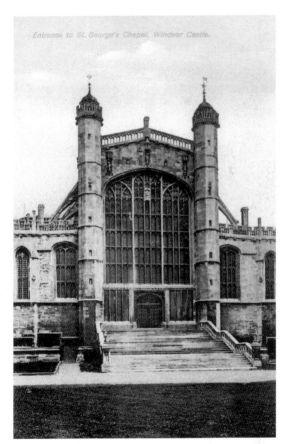

It was an auspicious day for Windsor when Edward III was born in the Castle on 28 November 1312. He later founded the Order of the Garter, which chose Windsor as its temporal and spiritual home. The origin of the order is obscure. Legend has it that in 1348, after Joan Fair Maid of Kent, Countess of Salisbury, dropped her garter at a ball, the King picked it up and, placing it around his knee, spoke the words *Honi Soit Qui Mal Y Pense* (Shamed be He Who Thinks Evil of It) which became the motto of the Order. To this day, the insignia of the Order is worn below the knee. It seems that at first the Order was only intended to form two teams for jousting, with the Sovereign leading one and the Prince of Wales (The Black Prince) the other. But Edward's intentions quickly became more serious, for in August 1348 he formed the priestly College of St George with a Custo and twenty-five canons. In addition there were to be twenty-five Poor Knights who were to attend mass daily as a substitute for the Companions of the Order. This institution survives today though on a modest scale: there are a Dean, three Canons, three minor Canons, and thirteen Poor Knights. Military Knights are retired officers of distinction.

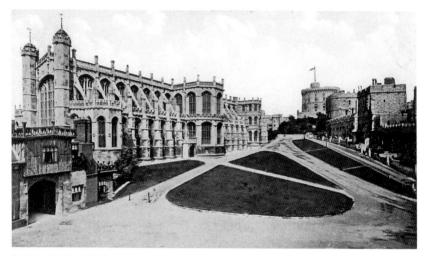

St George's Chapel before restoration in the 1920s and the many additions to come.

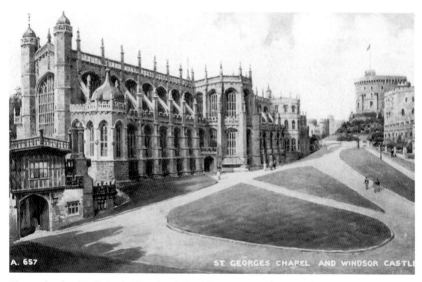

The south side of St George's Chapel with the delicate flying buttresses which take the weight of the stone-vaulted roof inside. It was restored in the 1920s with many of the features shown in the postcard above, such as the King's beasts mounted on the pinnacles on the roof, copper-domed roofs and the Chapel shop.

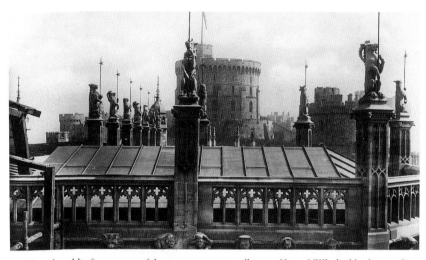

These heraldic figures, part of the recent restoration, illustrate Henry VIII's double claim to the throne through his Lancastrian mother and Yorkist wife. Similar 'bestial' parts of the original design were removed owing to their decayed state in 1682, on the advice of Sir Christopher Wren. They were later replaced in the 1920s restoration.

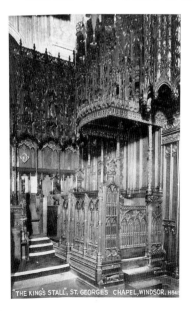

"THE KING'S STALL", ST. GEORGE'S CHAPEL, WINDSOR. H84H

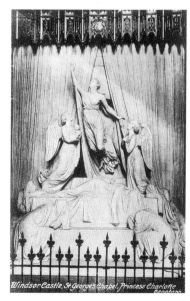

Windsor Castle, St George's Chapel, Princess Charlotte Cenotaph

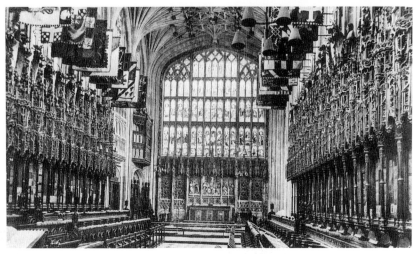

The choir of the Chapel looking east and west, showing the roof of the nave beyond. The magnificent fan-vaulting of the roof was constructed at the beginning of the sixteenth century and completed in 1528, as shown by the inscription beside the arms of Henry VIII in the centre above the choir screen. The rich carvings of the choir stalls date from about 1480 and contain exquisite craftmanship combined with a rare fund of invention. They portray solemn events such as Edward IV meeting Louis XI on the bridge at Picquiny and also such homely and possibly true scenes as dogs gobbling a poor man's dinner. Above the stalls hang the banners, swords and helmets of the present Knights of the Garter, while at the back of each stall is a collection of enamelled plates, the earliest dating from 1390, reciting in Norman French the arms and titles of the companion who occupied the seat during his lifetime.

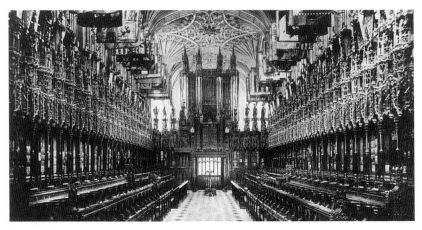

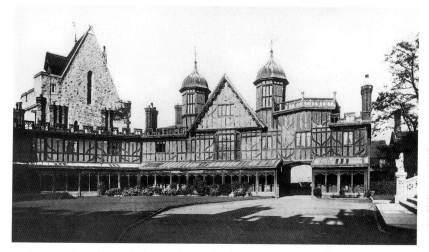

The Horseshoe Cloisters, built in red brick in the shape of a Fetterlock (one of the badges of Edward IV) is another range of buildings in Tudor style, standing to the west of St George's. Extensive restoration was necessary in 1870 and has left little of the original materials.

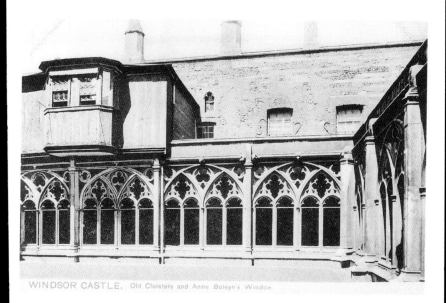

WINDSOR CASTLE. Old Cloisters and Anne Boleyn's Window.

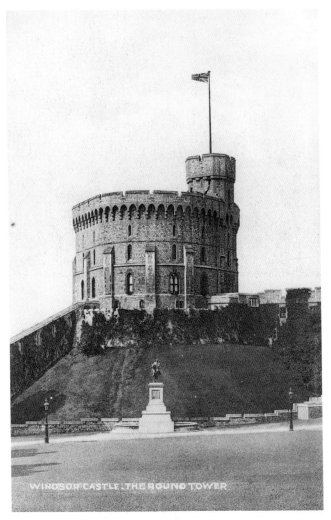

WINDSOR CASTLE THE ROUND TOWER

The form of the original is unknown, but it is probably similar to the present lay-out of the Castle, with an upper and lower bailey and a central artifical chalk mound. This mound, on which the Round Tower now stands, is 50 feet high and measures almost a 100 yards in diameter at the base. Provided with a well, which can still be seen beneath a bedroom floor in the Round Tower, it formed a secure keep to which a beleaguered garrison might retreat for a last stand. An extra 33 ft stone crown was added to the Round Tower to house the 73 ft flagstaff in 1804, under the supervision of Jeffrey Wyatt, George IV's architect.

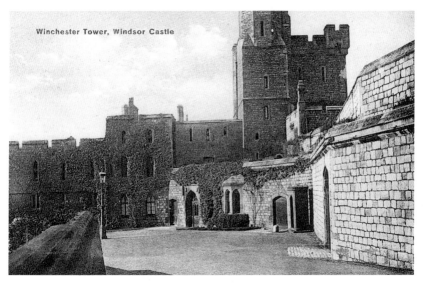

Winchester Tower and entrance to the North Terrace.

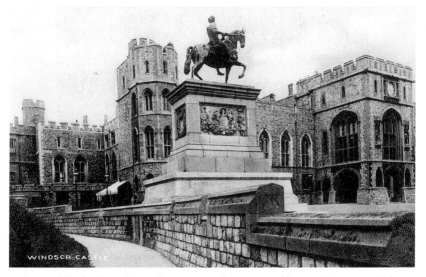

Statue of Charles II, as a Roman Emperor, erected as a memorial by one of his servants, Tobas Rustat, in 1679. The plinth carvings are by Grinling Gibbons.

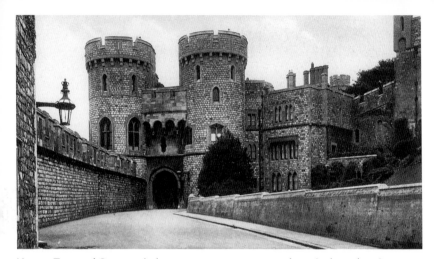

Norman Tower and Gateway, which was once a prison is now a residence. In the gardens, James I of Scotland first met his Queen, whose attendant, Catherine Douglas, made her heroic attempt to bar the door with her bare arm when the King's men came to murder him in 1437.

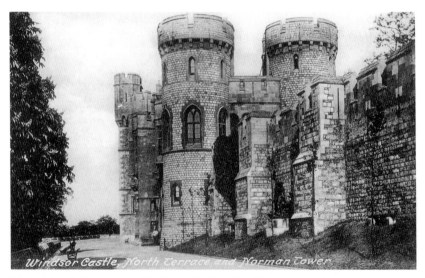

Windsor Castle, North Terrace and Norman Tower

Elizabeth I resided frequently at Windsor and built the North Terrace, now a favourite place with all those who visit the Castle, with views over Home Park, Brocas Meadows and Eton College, and with the Buckinghamshire foothills in the distance.

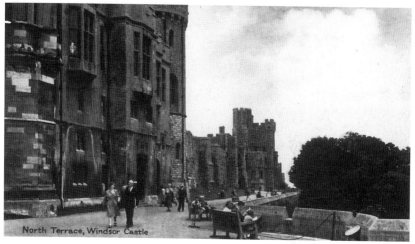

North Terrace, Windsor Castle

Henry VII's apartments on the North Terrace.

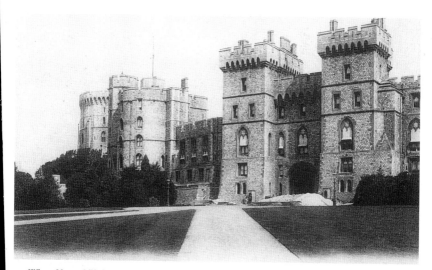

When Henry VII, Lancastrian and first Sovereign of the House of Tudor, rode up to the Castle with his young wife, they were acclaimed with joy, for the new Queen was Elizabeth of York, the Lady Bessie of the old ballads. In their marriage and subsequent children, the two great warring families of York and Lancaster were to be united at last.

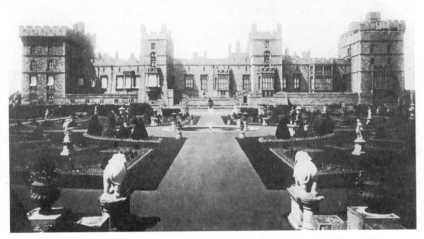

Next to the Victoria Tower comes the suite known as the King's Room in which George IV, William IV and the Prince Consort all died. Then come the White, Green and Crimson Drawing Rooms in which the Royal Family entertain their guests during Ascot Week. The card is dated 24 August 1905.

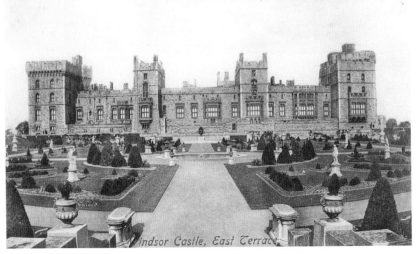

Have the elephants gone to help the war effort? The card is dated 9 July 1914.

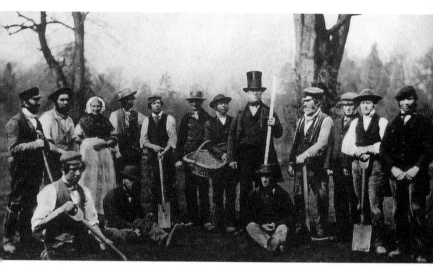

Gardeners on the Royal Estate, Windsor, *c.* 1855.

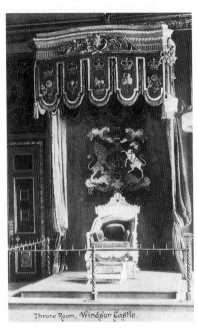

Throne Room, Windsor Castle.

The Throne Room, also known as the Garter Room, where Queen Victoria invested foreign sovereigns with the Order of the Garter and where King Haakon of Norway received the honour from Edward VII in 1906. Set into the walls is the full-length portrait of George I by Kneller.

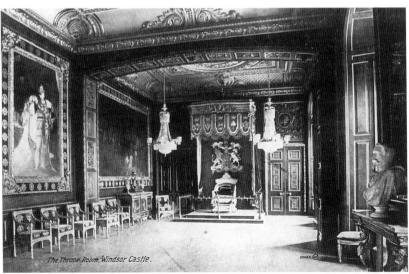

The Throne Room, Windsor Castle.

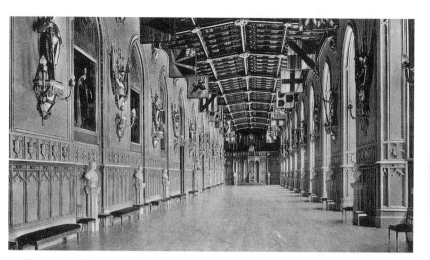

This Great Hall was originally constructed in the fourteenth century by Edward III. The shields on the ceiling and around the walls bear the coats of arms of the Knights of the Garter since the inception of the Order in 1348. The portraits are of Stuart and Hanoverian sovereigns of the Order of the Garter.

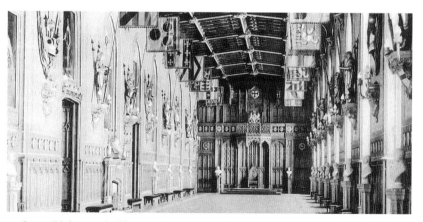

George IV, that great builder of royal homes, remodelled the private apartments, adding this famous Grand Corridor, which Disraeli lamented that he had to pace five times a day. The corridor played a great part in Victorian Court life, when the household and guests lined up there each evening to await the Queen before dinner and to bid her a formal good-night afterwards. Elegant ladies and infirm elder statesmen dreaded these ceremonies in the draughty corridor.

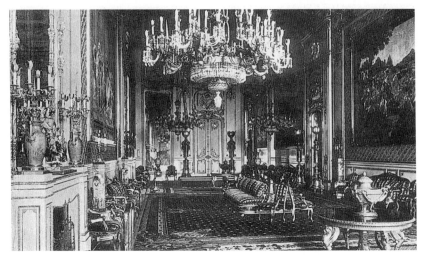

The ornate decorations designed for George IV were used to receive guests at functions held in the Waterloo Room or the St George's Hall.

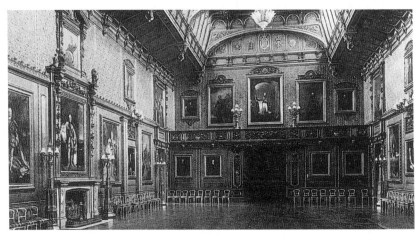

George IV conceived a grandiose scheme for commemorating the victory over Napolean at Waterloo and commissioned Sir Thomas Lawrence to paint a series of all the monarchs, statesmen and warriors who had shared in the Emperor's defeat. George IV never lived to see his scheme completed. His own portrait in Garter Robes stands beside his father George III over the fireplace, whilst his brother, William IV, stands beyond.

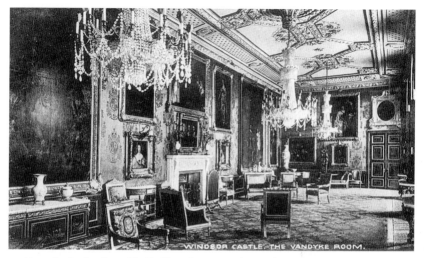

Above the fireplace hangs Van Dyck's triple portrait of King Charles II, painted for despatch to Rome so that the sculptor Bernini could carve a bust of the King without undertaking the journey to London. The painting was brought back to England in 1802.

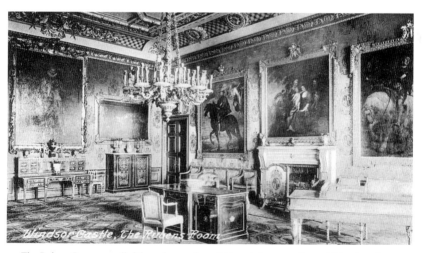

The Rubens Room, so-called from the number of this artist's masterpieces which adorn the walls. It was here that famous actors and theatrical companies used to be commanded to perform before Queen Victoria. The room also contains many examples of Louis XIV furniture and oriental porcelain.

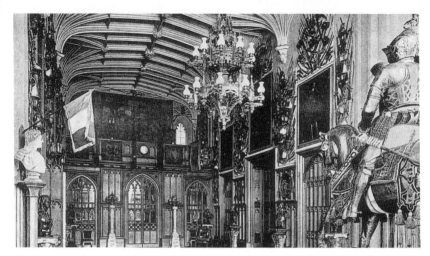

The armour on the mounted figure, made at Greenwich in 1585, was worn by the King's champion at the coronation banquet of George I. The flag (red, white and blue) is rendered annually by the Duke of Wellington on 18 June, the anniversary of the battle of Waterloo, as rent for the Stratfield Saye estate in Hampshire. Below is a view of the Picture Gallery at Windsor Castle.

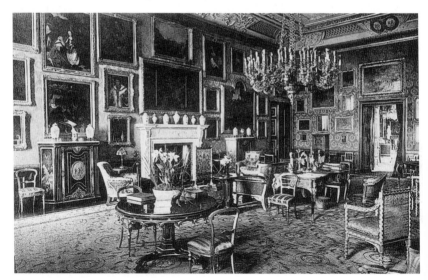

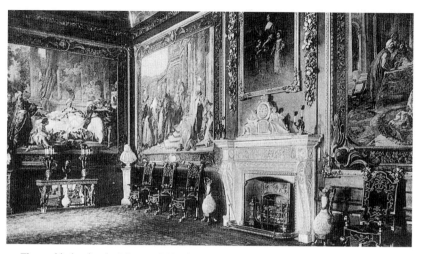

The marble fireplace by J. Bacon, 1789. This was removed from Buckingham Palace by William IV and installed here. The bust in the corner is of Handel, whose music was often played in this room at concerts given by George III.

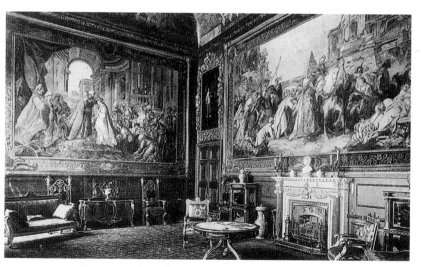

Around the walls are tapestries woven in Gobelin's factory in France in the 1780s; the wood carvings surrounding the pictures are masterpieces of Grinling Gibbons. The paintings by Jean Francois de Troy (1679–1752) depict the story of Ester the Jewish Queen of Ahasuerus and the King of the Persians, who saved her compatriots from the massacre ordered by her husband.

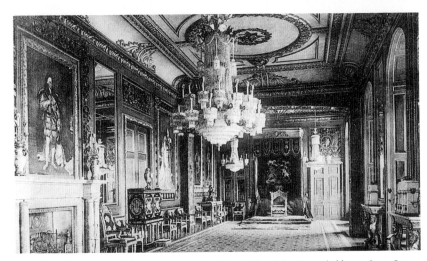

The Throne Room is used for private ceremonies of the Order of the Garter, held every June. Set in the walls are full-length portraits of British sovereigns in their Garter Robes from George I to Queen Victoria.

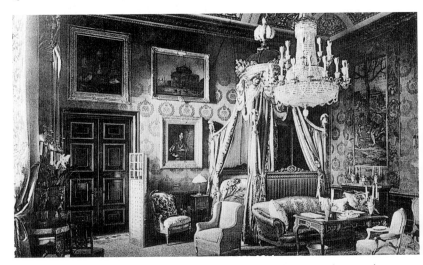

Originally Charles II's State Bedroom, this room was occupied in the nineteenth century by foreign sovereigns during State visits to Windsor. The bed was made by G. Jacob in the reign of Louis XVI and its foot bears the initials of the Emperor Napoleon III and the Empress Eugenie, who visited Windsor in 1855.

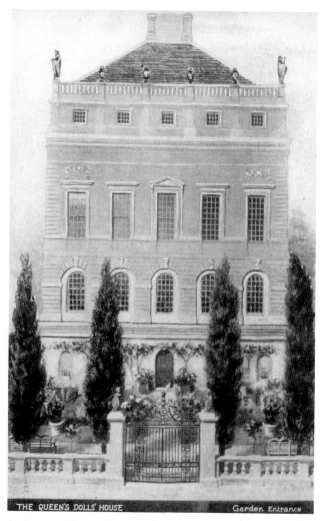

THE QUEEN'S DOLLS' HOUSE *Garden Entrance*

The Garden Entrance. This wonderful miniature palace, the great show-piece of the British Empire Exhibition, will be of permanent interest for it depicts a representative mansion of the twentieth century. A marvellous company of over 1,600 artists and craftsmen have combined to produce the marvel. The scale is one inch to the foot and the effect is harmonious and realistic. The picture shows the beautiful garden with its handsome entrance gates, tall trees and clustering roses, clipped hedges and seats, lawns and flowers, shelter for the birds, fairy ring in the grass, and even a dog waiting on the step.

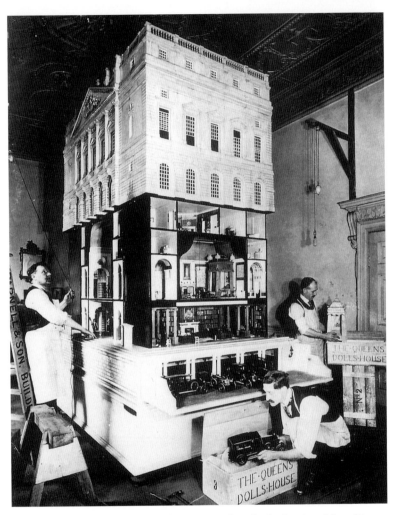

Queen Mary's Doll's House, one of the largest ever made under the direction of the architect Sir Edward Lutyens and presented to Queen Mary in 1924 as a symbol of good will. It measures 8' by 5' and is built on a scale of 1:12, so that if it were to have inhabitants they would be six inches tall. Most of the tiny paintings were executed by noted British artists of the period, including Sir Alfred Munnings, and the diminutive books, which are barely an inch square on the Library shelves, were specially written and inscribed by contemporary authors such as Rudyard Kipling and G.K. Chesterton. The image shows the Queen's Doll's House being packed up in order to be exhibited at the British Empire Exhibition at Wembley in 1924.

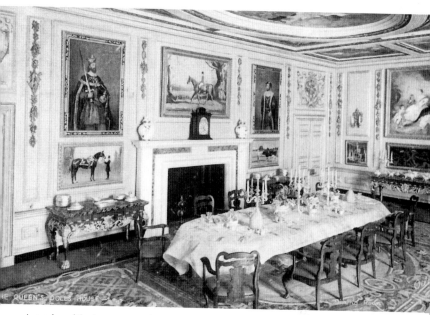

A stately and fascinating room for a banquet is the Dining Room of the Queen's Doll's House. It is 42 inches long, 20 inches wide, 15 inches high, the scale being 1 inch to 1 foot. It has a painted ceiling and Royal portraits and pictures in miniature by eminent artists adorn the walls. The table, 2¼ inches high, is set for a dinner party with a snowy damask tablecloth, and is fully equipped, with flowers and fruit, china, cutlery and silver candleabra all complete to the smallest detail.

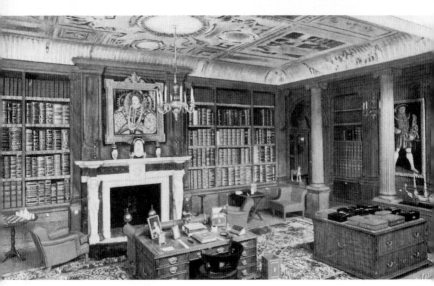

The Library ceiling of the Queen's Doll's House was painted by William Walcot RBA. The picture of Queen Elizabeth I is by William Nicholson, and the portrait of Henry VIII at the end of the room is a copy by Sir Arthur Cope, RA, of the original by Holbein. 'The Bronze Horse' is by Herbert Haseltine and is a model of one of the King's champion shire horses. The large walnut cabinet, on which are reproductions of the King's despatch boxes from the various Ministries, is one of a pair which contain 750 miniature water colours, etchings and drawings contributed by the leading artists of the day.

Opposite: Crowds gathering on the corner of Peascod Street and firemen pumping water to fight the blaze.

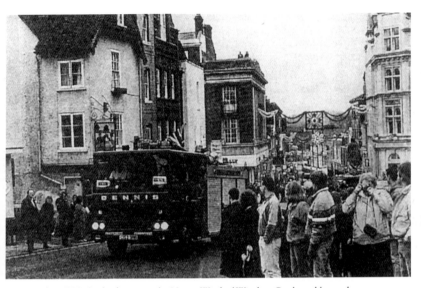

In November 1992, fire broke out in the Upper Ward of Windsor Castle and burned continuously for over twenty-four hours. Two hundred and fifty firemen laboured over fifteen hours using one and a half million gallons of water to extinguish the flames. While over one hundred rooms, including nine principal rooms, were lost or damaged, almost all of the contents were successfully evacuated and rendered capable of repair. Fortunately, many rooms were being rewired so a considerable amount of valuables had already been stored elsewhere. However, the damage to the structure, fabric and decoration was grave. As a result of this fire, the most ambitious reconstruction process of Windsor Castle since the Second World War has been underway.

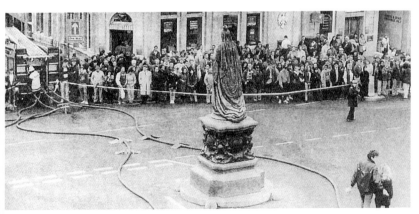

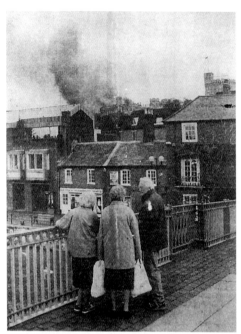

Spectators standing on Windsor Bridge wonder what the smoke was all about. And below, a view of Windsor Castle from the bridge.

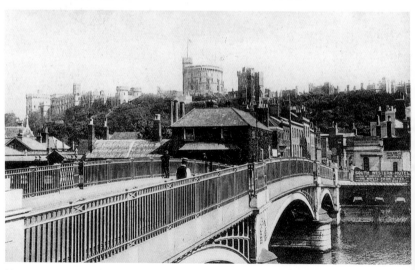

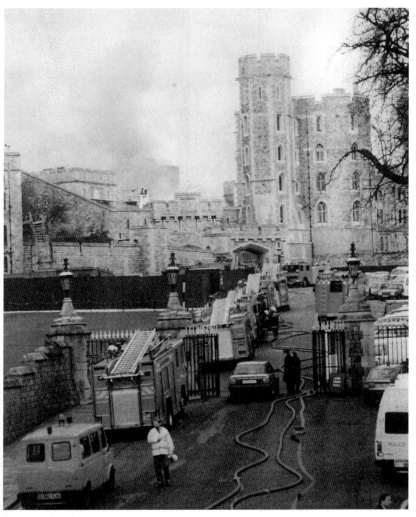

Castle Hill entrance, with St George's Gate and Edward III, or Devil's Tower, in the background and the arrival of more fire engines to fight the blaze.

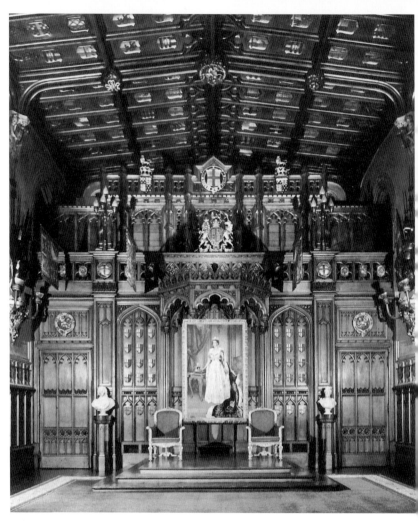

Before.

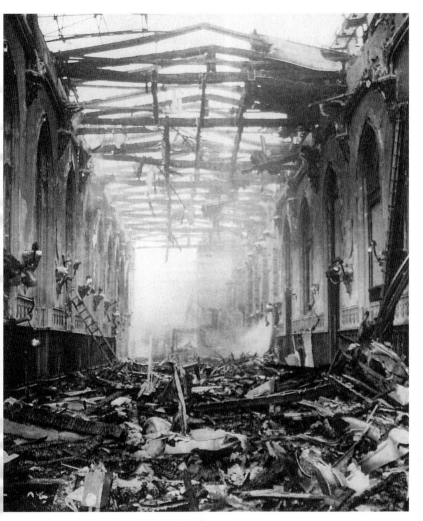

After. The result of the fire in St George's Hall.

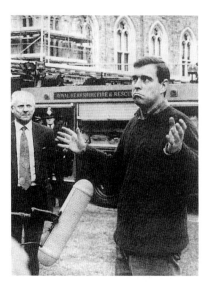

Soldiers of the Household Cavalry from Combermere Barracks, and others, rescue historic valuables under the watchful eye of the law.

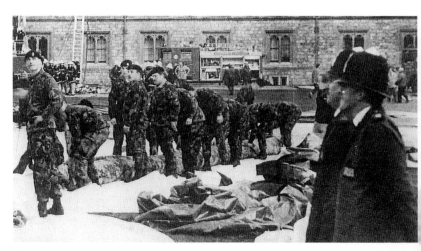

Two

Windsor Great Park

Windsor Great Park, covering about 4,800 acres, evolved out of the Saxon and medieval hunting forest. There are two more Royal residences, Royal Lodge and Cumberland Lodge, working farms and a school. The man-made lake of Virginia Water was created by William Duke of Cumberland on his appointment as Ranger of Windsor Great Park in 1746. He was greatly assisted by Sandy Brothers and almost all of the heavy work was done by the Duke's soldiers, probably after having fought with him at Culloden. The Obelisk and Great Meadow Ponds were also created at this time.

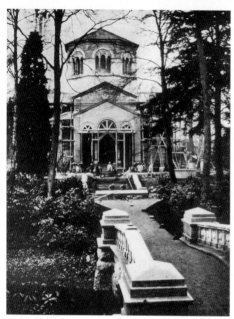

The Royal Mausoleum at Frogmore, a cruciform building in the Romanesque style, was built in 1863, although the interior was not completed until 1868. The Prince Consort's body was transferred here from St George's Chapel a year after his death.

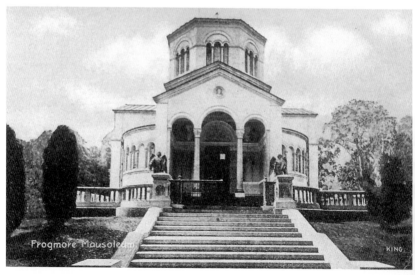

Frogmore Mausoleum

KING.

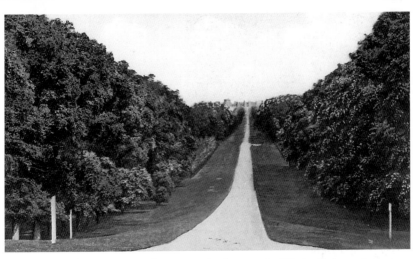

Charles II, on his return from exile, was immediately attracted to Windsor for he saw it as not only a pleasant place, but also a kingly residence that could be made to compare favourably with Louis XIV's grand palace at Versailles, (the building of which was then just taking place). With this object in view he created the Long Walk, 3 miles long and 240 yards wide. The avenue was planted with elms in 1685; they survived until age and disease demanded their replacement in 1946 with alternate horse chestnut and plane trees.

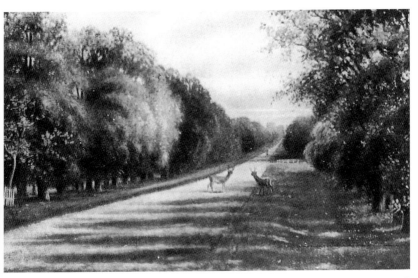

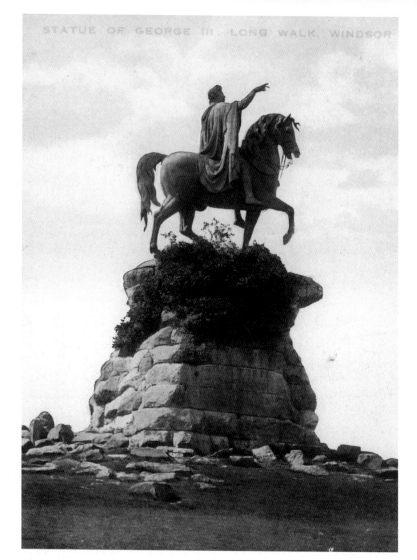

Charles II was not able to bring his avenue up to the Castle walls as he would have wished.
This was only achieved in 1824 by George IV who swept away the houses, including one that
was designed by his father, and erected at the far end of the Long Walk upon Snow Hill, a
monster statue of George III, in the guise of a Roman Emperor astride a large copper horse.

The Lodge, Frogmore Park.

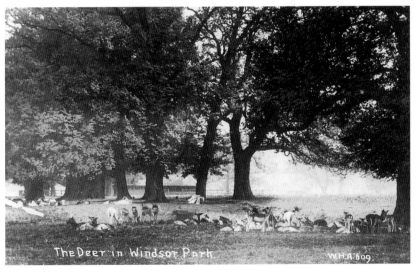

The Deer in Windsor Park.

W.H.A. 609

Postcard, July 1924, sent from 46 Alma Road, of the deer in Queen Anne's Ride on the Ascot Road, with the deer pen in the trees.

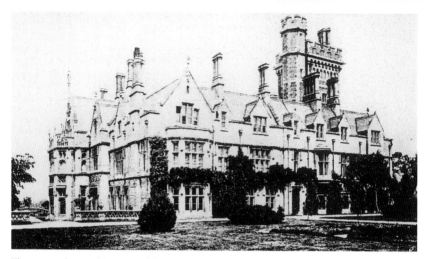

The wartime home of Dr Barnardo's Boys, who were bused to the Royal Free School. The exterior has changed little since Victorian days when Queen Victoria liked to drive here for afternoon tea.

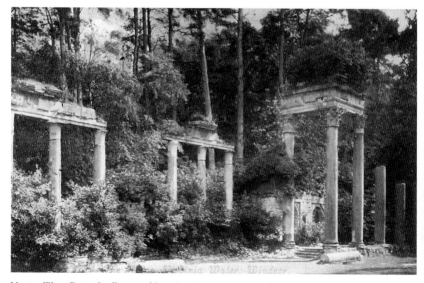

Virgina Water Ruins finally arrived here from Lepcis Magna on the coast of North Africa in 1826 after ten years of transport difficulties.

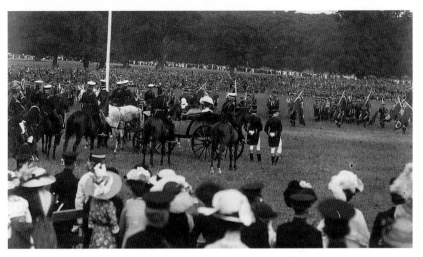

The writing on the rear of this postcard, dated 4 July 1911, reads: 'We are watching the review of Boy Scouts at Windsor Great Park.'

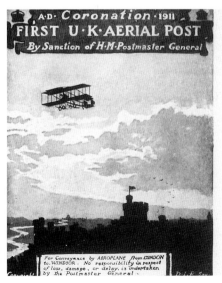

(Address only to be written here.)

Coronation aerial postcard, September 1911, for conveyance by aeroplane from London to Windsor. 'No responsibility in respect of loss, damage or delay, is undertaken by the Post Master General.'

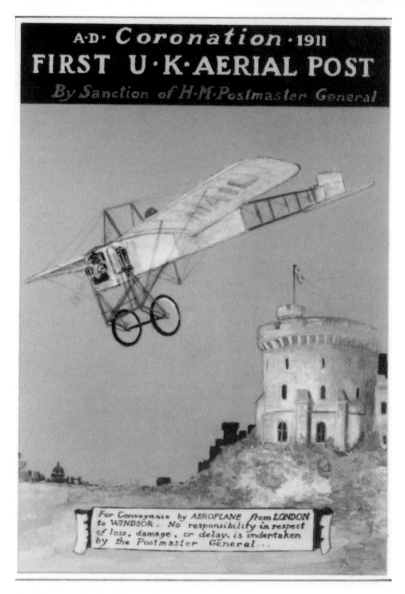

A replica postcard of a U.K. Aerial Post aeroplane.

Three

Royalty

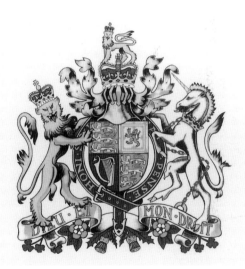

The present Royal Arms date from the accession of James VI of Scotland to the English throne in 1603, when the arms of Scotland were added to those of England and, at the same time, the arms of Ireland were introduced, providing the second and third quarterings we know today. At that time the arms in the first and fourth grand quarters were themselves quarterings showing the three golden lilies of France at the first and fourth, thereby expressing the ancient claim of the Plantagenets to the French throne. The three gold lions of England were in the second and third quarters, as in the arms of Elizabeth I shown below. In 1801 the arms of France were removed and from 1837, upon the accession of Queen Victoria, the Royal Arms took their present form without the escutcheon of the Hanoverian Kings.

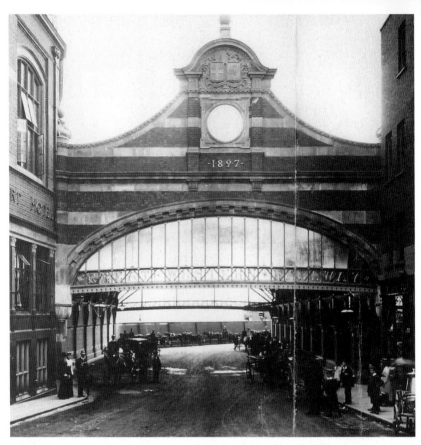

Station Approach, originally known as George Street, was an infamous street of vice in the nineteenth century. The ornate arcade, originally built in 1849 for the Great Western Railway, was rebuilt in 1897 for Queen Victoria's Diamond Jubilee. Complete with handsomely appointed Royal Waiting Rooms, Queen Victoria and her large family arrived here from London on their private railcars.

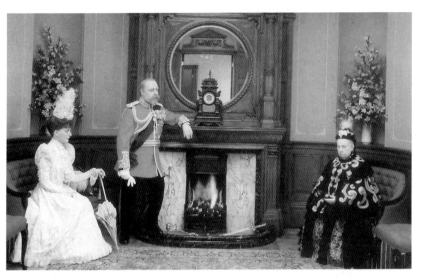

Two scenes from the Madame Tussaud's Royalty and Empire Exhibition of Queen Victoria's Diamond Jubilee of 1897, which was opened in 1984. Pictured are Queen Victoria and the Prince and Princess of Wales in the Royal Waiting Room and Queen Victoria and her guests approaching her carriage.

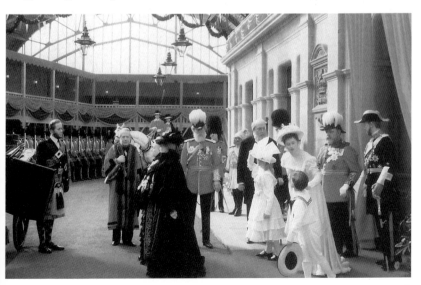

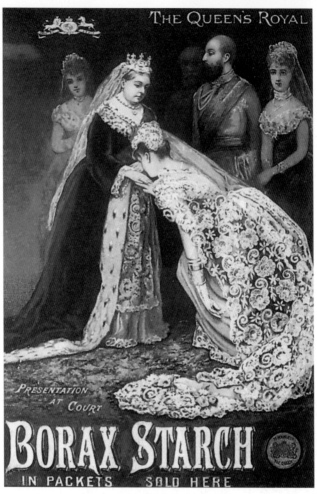

Queen Victoria, born in May 1819, was the only child of George III's fourth son, Edward Duke of Kent, and of Victoria of Saxe-Gotha. She succeeded her uncle, William IV, in 1837 when she was only 18 years old. Victoria ruled for 63 years, longer than any other British monarch. In 1840 she married her cousin Prince Albert of Saxe-Coburg-Gotha and they had nine children, five girls and four boys. When Albert died in 1861, Victoria retired into complete seclusion at Windsor and it was only the tact of Benjamin Disraeli that at last persuaded her to emerge. Victoria was proclaimed Empress of India in 1877 and the Diamond Jubilee in 1897 demonstrated her immense popularity with the British people. She died in 1901 and is buried beside Albert at Windsor.

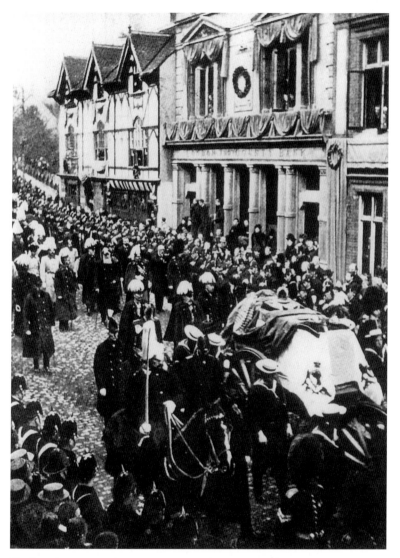

The funeral procession of Queen Victoria in High Street. Behind the gun carriage
drawn by sailors, walk King Edward VII, Kaiser Wilhelm II and the Duke of Connaught.
The London and County Bank and the National Westminster Bank (which are now
demolished) are also pictured.

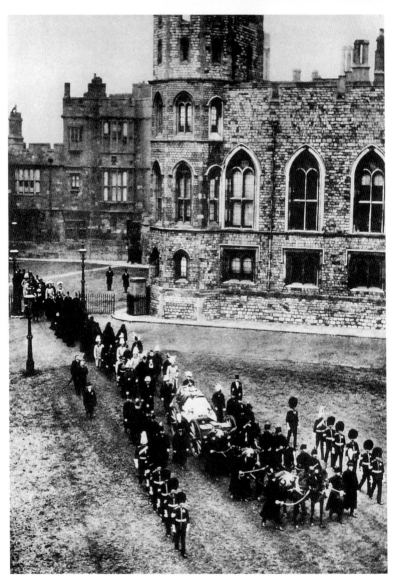

Queen Victoria's funeral procession passing through the Quadrangle to the Mausoleum at Frogmore, February 1901.

NOTICE.

THERE WILL BE

NO DELIVERY

OF LETTERS BY THE

LONDON DISTRICT POST

IN THE AFTERNOON OF

Tuesday, the 10th March, 1863,

THE DAY APPOINTED FOR THE

MARRIAGE

OF HIS ROYAL HIGHNESS THE

PRINCE OF WALES.

Letters for the Night Mails will be collected from the Town Pillar Boxes at 5 P.M., and from the Town Receiving Houses at 5.30. P.M., but there will be no Collection, either from the Pillar Boxes or the Receiving Houses, after the hours named.

Letters to be forwarded by the *Morning Mails* on Wednesday, the 11th March, must be posted either at the Head District Offices, the Branch Offices at Lombard Street and Charing Cross, or in the Town Pillar Letter Boxes, as there will be no Collection for such Mails from any Town Receiving House.

There will be no despatch of Mid-day Mails from London to the Provinces on Tuesday.

No Money Order business will be transacted either in London, or at Places within the Twelve Mile Circle, after 12 o'Clock. Noon

Circulation Department,
 General Post Office,
 March, 1863.

W. BOKENHAM,
Controller.

G 1000 2| 63

A postal notice issued by the London District Post, March 1863, on the occasion of the Prince of Wales' marriage.

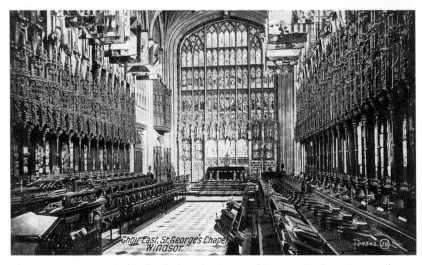

The marriage ceremony of Edward and Alexandra, Prince and Princess of Wales, in St George's Chapel, 10 March 1863. It was the first Royal wedding to be held here since that of Henry I in 1122. A more beautiful setting could hardly be imagined than that of the choir with its fan-vaulting roof and colourful banners hanging from the stalls of the Knights of the Garter.

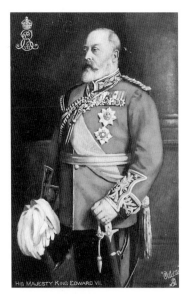

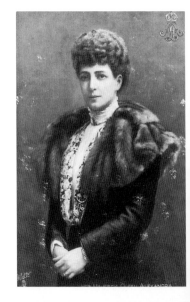

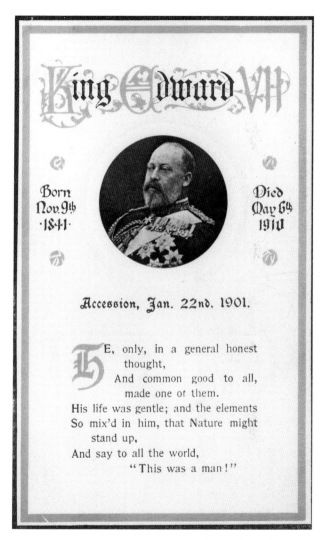

King Edward VII

Born
Nov. 9th
·1841·

Died
May 6th
1910

Accession, Jan. 22nd. 1901.

HE, only, in a general honest
thought,
And common good to all,
made one of them.
His life was gentle; and the elements
So mix'd in him, that Nature might
stand up,
And say to all the world,
"This was a man!"

Already bedridden and suffering a serious attack of bronchitis, on 6 May 1910 King Edward smoked a large cigar at noon following a light lunch and then suffered a series of heart attacks. As Edward's life slipped away, the Prince of Wales was able to tell him that the King's horse, Witch of the Air, had won that afternoon at Kempton Park. It was appropriately enough, virtually the last news he heard. Halley's Comet blazed in the night skies as the King died that evening at 11.45.

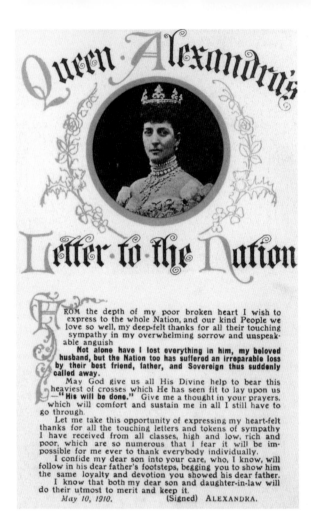

Queen Alexandra's Letter to the Nation

FROM the depth of my poor broken heart I wish to express to the whole Nation, and our kind People we love so well, my deep-felt thanks for all their touching sympathy in my overwhelming sorrow and unspeakable anguish.

Not alone have I lost everything in him, my beloved husband, but the Nation too has suffered an irreparable loss by their best friend, father, and Sovereign thus suddenly called away.

May God give us all His Divine help to bear this heaviest of crosses which He has seen fit to lay upon us —"His will be done." Give me a thought in your prayers, which will comfort and sustain me in all I still have to go through.

Let me take this opportunity of expressing my heart-felt thanks for all the touching letters and tokens of sympathy I have received from all classes, high and low, rich and poor, which are so numerous that I fear it will be impossible for me ever to thank everybody individually.

I confide my dear son into your care, who, I know, will follow in his dear father's footsteps, begging you to show him the same loyalty and devotion you showed his dear father.

I know that both my dear son and daughter-in-law will do their utmost to merit and keep it.

May 10, 1910. (Signed) ALEXANDRA.

Alexandra, born in 1844, the eldest daughter of Christian XI of Denmark, was carefully selected by Queen Victoria as the wife of the heir to the British throne. Edward married her in St George's Chapel in 1863 when she was only 18 years of age. After a carefree upbringing, Alexandra faced the formality of the English Court with great dignity, earning widespread public affection. She was a devoted mother to her children - three daughters and two sons. Her eldest son Albert, who would have become King of England, died of influenza at the age of 28. Alexandra established the Queen Alexandra Imperial (later Royal) Army Nursing Corps in 1902. She died in 1925 and her charitable help for nurses and hospitals is still remembered on Alexandra Rose Day.

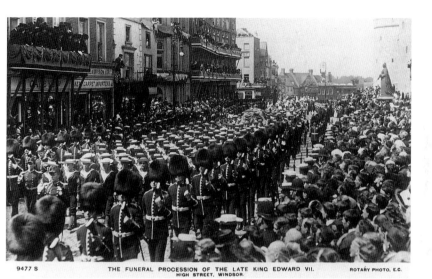

9477 S THE FUNERAL PROCESSION OF THE LATE KING EDWARD VII. ROTARY PHOTO. E.C.
HIGH STREET, WINDSOR.

The funeral procession of the late King Edward VII, passing Caleys and Denyer & Dyson, importers of carpets, court dressmakers, silk mercers etc, with the telephone number of Windsor 1.

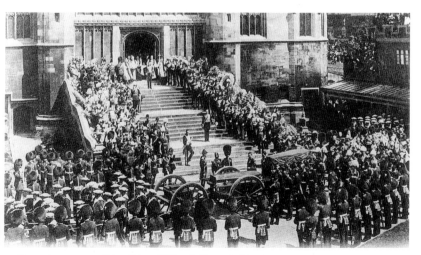

Funeral procession of King Edward VII at St George's Chapel.

A Right Royal Drink

HORNIMAN'S PURE TEA

Albert Edward, Prince of Wales, born in 1841, was called 'Bertie' by his family. He was prevented from exerting any political influence until the latter part of his life and partly made up for this by involving himself in a life of high society, the theatre and sport. He was well liked by the public but Queen Victoria was sometimes dismayed by his activities. The Prince of Wales became King Edward VII at the age of 59. He had great charm but towards the end of his life he became increasingly difficult to please. He died in 1910 at the age of 69, and was succeeded by his second son, who became George V.

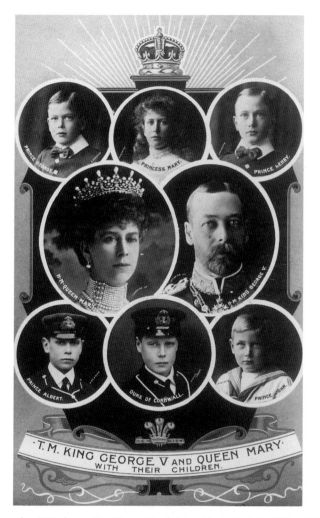

This postcard, c. 1916, depicts King George V and Queen Mary with their children: Prince Edward Albert Christian George Andrew Patrick David, Duke of Cornwall, created Prince of Wales in 1911 (Duke of Windsor), born 23 June 1894; Prince Albert Frederick Arthur George, (Duke of York), born 14 December 1895; Princess Victoria Alexandra Alice Mary (Countess of Harewood), born 25 April 1897; Prince Henry William Frederick Albert (Duke of Gloucester), born 31 March 1900; Prince George Edward Alexander Edmund (Duke of Kent), born 20 December 1902; Prince John Charles Francis, born 12 July 1905 and died 18 January 1919.

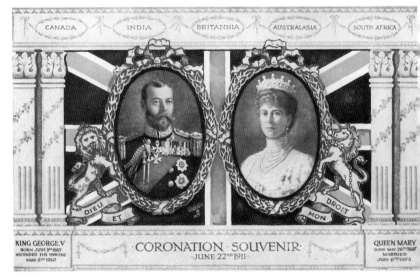

Two souvenir cards from the 1911 Coronation of King George V and Queen Mary.

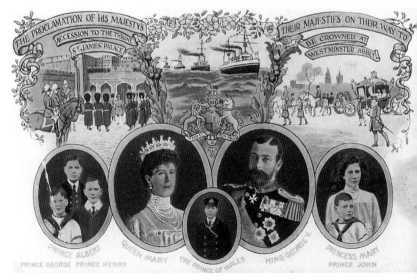

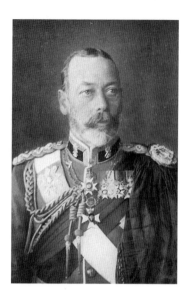

Official portrait of King George V and commemorative booklet on the occasion of the 25th anniversary of his reign.

THEIR MAJESTIES KING GEORGE V AND QUEEN MARY

THIS is the twenty-fifth year of the reign of Their Majesties King George and Queen Mary.

King George was born on June 3rd, 1865. At the age of 12 he became a cadet in the training ship "Britannia," and his enthusiasm for the sea quickly earned him the affectionate title of "Our Sailor Prince."

In 1893 he married Princess May, as the Queen was then called, and when, in 1910, Their Majesties came to the throne, there began one of the most eventful reigns in English history.

In 1914 King George was called upon to guide his people through the most exacting struggle ever faced, and his personal example was largely responsible for the steady courage shown during those years.

It has been said of King George and Queen Mary that "There have been no Sovereigns in history who have moved so much among their people," and this is undoubtedly an important reason for the close relationship between their Majesties and their subjects.

Not only have Royal visits been made to practically every city of importance, but also to the colonies and overseas dominions, where the same personal contact has endeared Their Majesties to the people of the Empire.

The relief and national rejoicing that greeted the King's recovery from his serious illness of 1928 show clearly the affection in which Their Majesties are held.

LONG MAY THEY REIGN

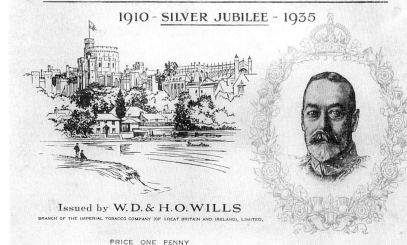

THE REIGN OF KING GEORGE V

1910 - <u>SILVER JUBILEE</u> - 1935

Issued by W.D. & H.O. WILLS

BRANCH OF THE IMPERIAL TOBACCO COMPANY (OF GREAT BRITAIN AND IRELAND), LIMITED.

PRICE ONE PENNY

Collector's corner. A series of cigarette cards were issued of the life of George V, together with an omnibus edition of Commonwealth stamps to forty-four countries of the Commonwealth, depicting Windsor Castle.

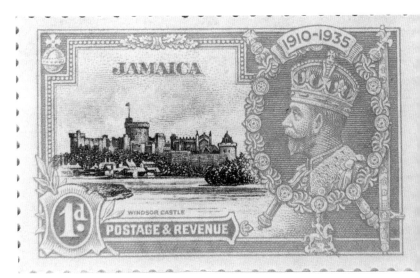

JAMAICA

1910-1935

WINDSOR CASTLE

1d.

POSTAGE & REVENUE

KING GEORGE SILVER JUBILEE
1910 ——— 1935

HIS MAJESTY'S SEVENTIETH BIRTHDAY
1865 ——— June Third ——— 1935

Francis J. Czerniak

3369 E. Edgemont St.,

Phila., Penna.

An illustrated 70th birthday cover of 3 June 1935.

Stamps in Australia, New Zealand, India and also this specimen of a stamp from Canada were
printed by their own Governments to be different to the Commonwealth issues.

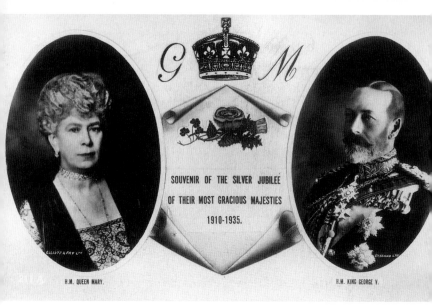

G M

SOUVENIR OF THE SILVER JUBILEE
OF THEIR MOST GRACIOUS MAJESTIES
1910-1935.

H.M. QUEEN MARY.

H.M. KING GEORGE V.

The Silver Jubilee of King George V emphasises the extraordinary respect and affection in which he was held by all his peoples. No other constitutional monarch could deserve the tributes in such full and heartfelt measure. The repository of universal trust, he was the very essence of the unity of the British Commonwealth. His reign has covered not only the age of scientific miracles but the greatest war in history and a period of unparalleled unrest. Institutions and traditions, morals, philosophies and religions have everywhere been attacked by humanity in a delirium of doubt. Systems of government and statesmen have been called to account and declared bankrupt. Unemployment has inspired worldwide misery.

Opposite: Mourning card commemorating the death of King George V.

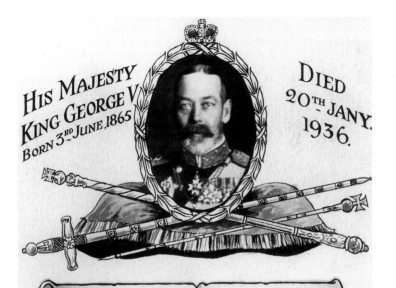

HIS MAJESTY
KING GEORGE V
BORN 3RD JUNE, 1865

DIED
20TH JANY.
1936.

IN MEMORIAM—
"OUR GRACIOUS KING."

———

THE KING IS DEAD,
 AND ROUND HIS ROYAL BED,
AN EMPIRE MOURNS
 ITS WELL-BELOVED HEAD.

THUS, IN THE QUIET NIGHT,
 HE PASSED INTO THE LIGHT,
AND AS THE WHOLE WORLD KNOWS,
 "HIS LIFE MOVED PEACEFULLY
TOWARDS ITS CLOSE."

THE KING IS DEAD:
 BUT LET THIS NOW BE SAID:—
"HE LIVES IN LIVES MADE NOBLER
 BY THE NOBLE LIFE HE LED."

—*Allan Junior.*

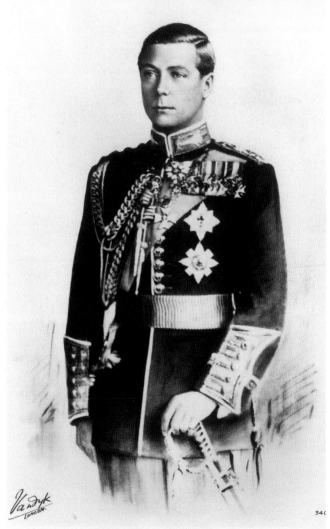

H.M. KING EDWARD VIII.

Born at White Lodge, Richmond Park on 23 June 1894, Edward VIII succeeded as King of Great Britain and the Dominions beyond the seas and Emperor of India on 20 January 1936, at the age of 41.

**WINDSOR CASTLE AND ST GEORGES
CHAPEL FROM THE RIVER**

1ᵈ
POSTAGE
POSTED at
WINDSOR

WINDSOR PHILATELIC COUNTER

16ᵖ

1 0 DEC '86

50TH ANNIVERSARY
OF THE ABDICATION OF
KING EDWARD VIII
(DUKE OF WINDSOR)

SIGNING OF ABDICATION 10TH DEC 1936
BROADCAST TO THE NATION 11TH DEC 1936

AN EXTRACT OF THE KING'S FINAL BROADCA
TO THE NATION FROM WINDSOR CASTLE

"But you must believe me when I tell you tha
have found it impossible to carry the hea
burden of responsibility and to discharge
duties as King as I would wish to do, with
the help and support of the woman I love, a
I want you all to know that the decision I ha
made has been mine, and mine alone."

For more than a year after the death of King George V, the Castle was not used as a Royal residence, though it was the scene of the historic abdication broadcast of Prince Edward, no longer King Edward VIII and not yet Duke of Windsor. Millions of men and women all over the world on that night of 11 December 1936 heard the announcement. This is Windsor Castle and His Royal Highness Prince Edward. The broadcast which moved this vast audience came from a small back room in the Augusta Tower which he had always occupied as Prince of Wales. Back in Plantagenet days there had been an Edward of Windsor, named from his birthplace. Twenty-seven kings and queens had reigned between, and now another prince took the title from the Royal home, which, under his father's edict, had provided the reigning house of Britain with its family name.

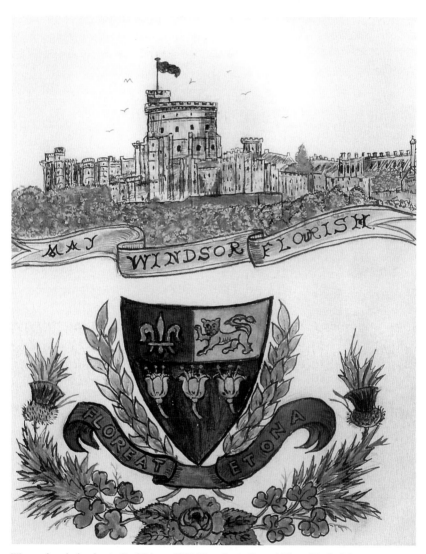

Water-colour by local artist Fred Pike, c. 1924. Note the spelling of 'Flourish' - the 'u' an afterthought?

Four

The River Thames

The coat of arms on Windsor Bridge.

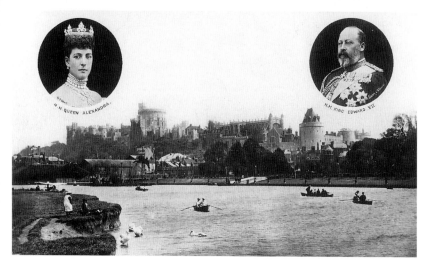

Windsor Castle from the north-west, silhouetted against the evening skyline, its many towers and turrets reflecting the rays of the setting sun. On the left is the Upper Ward, with the State Apartments overlooking the North Terrace; on the right stands Henry III's Curfew Tower, one of the most ancient of the Castle's buildings, and rising above the Lower Ward is the graceful roof of St George's Chapel. From the Round Tower, which dominates the whole of this historic Royal home, the Sovereign's Standard flutters in the breeze. Pictured below are Alexandra Gardens with the Castle in the background.

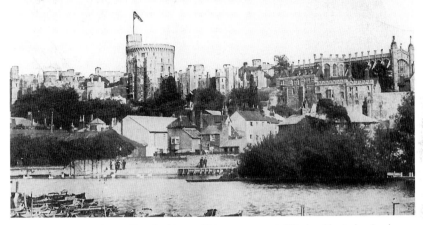

Many enterprising firms of boat builders and hirers sprang up in Windsor like Arthur Jacobs, who built and hired out craft for leisure by the hour; day or weekly bookings were supplied with a pull down awning for night sleeping, as in Jerome K. Jerome's classic, *Three Men in a Boat*. This is a view of before 1902, with no Theatre Royal, which wasn't rebuilt until 1903. Pictured below is a view of the Castle from Eton College Boathouse.

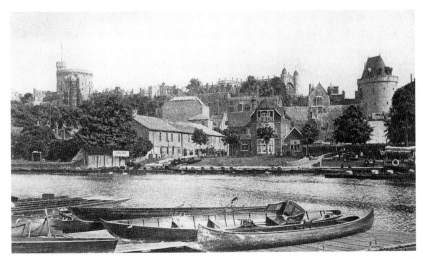

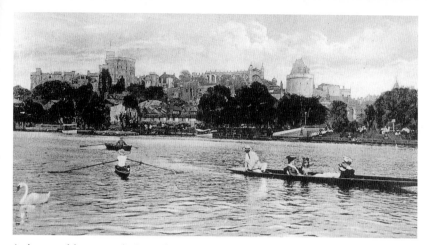

At the turn of the century the River Thames was in its heyday; this card is dated 7 September 1905. Correspondence on the rear is as follows: 'Many thanks for the P.C. I finished putting my P.C.s in the albums last night, I have 1,216 now.' (Some collection)

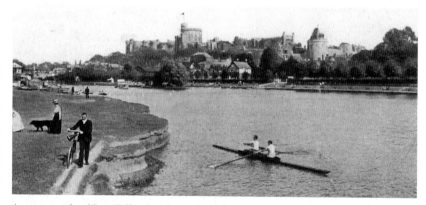

A common sight of Eton College boys being coached on the river. Correspondence on the rear is as follows: '5.10 pm. August 7th 1928, Bank Holiday. Just finished tea on the River Bank, where Chappy saw the Egham Regatta. I met Gabie at Langley and rode through Windsor Great Park and Englefield Green to Egham, lovely day. We are now going along the tow-path towards Datchet and Windsor and back to Langley. I left home at 7.30 am, the Primus behaved well, left before the post came this morning.'

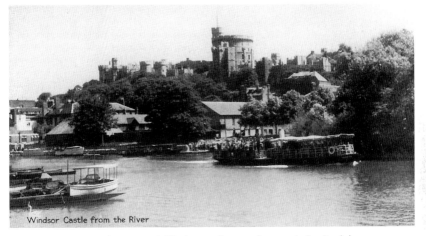

Windsor Castle from the River

Steamer trips were a favourite with Windsorians between the wars. Arthur Jacobs' steamers included the Empress of India, Windsor Castle and the Windsor Belle.

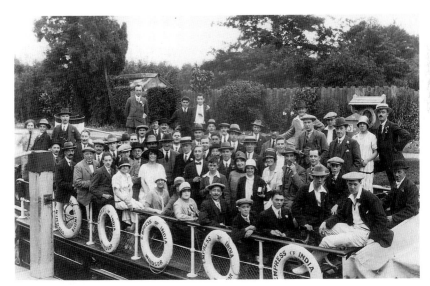

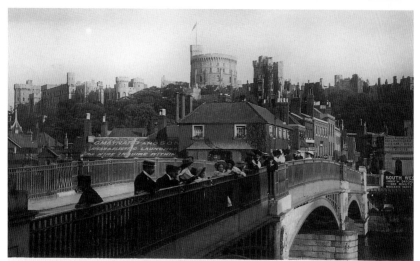

Windsor Bridge to Eton was built in 1823 of cast iron to replace the wooden bridge linking the two towns which had stood since the thirteenth century; the tollgates were removed in 1898. The advertisement below is on the roof of Maynard's Thames Side offices.

Five

Town and Shops

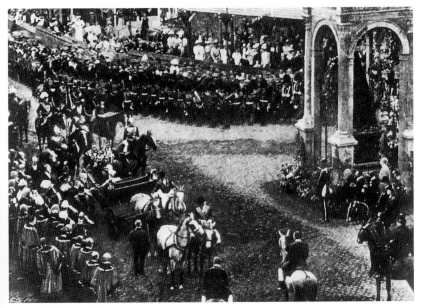

Queen Victoria receiving an address of congratulations from the Mayor and Corporation of Windsor on 23 June 1897, opposite her statue, which then had a stone canopy.

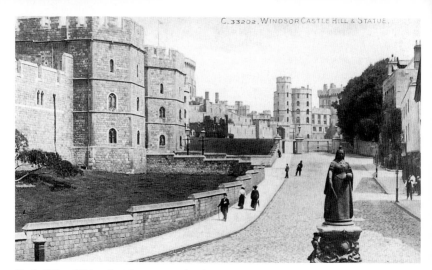

Castle Hill, c. 1906, with a Victorian post box, bottom left. Probably the most and best loved of Victorian pillar boxes are those known as Penfolds, which were made between 1866 and 1879. They are named after their designer, the architect, J.W. Penfold.

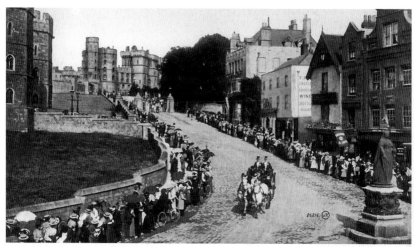

The statue of Queen Victoria marks the site of the medieval Market Cross where all public proclamations were, and still are, made. On the right are the Castle's grocers, F. Pratt, later to be Waitrose's, and, at the present, the Woollen Mill. The card is dated 4 June 1911.

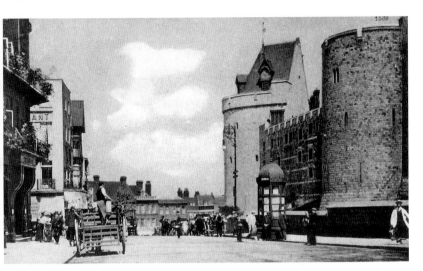

Tradesmen delivering to the White Hart by horse and cart, the transport of the day. The large sign over the building on the left advertises Boot's Chemist. On race days the horse buses also waited here to take passengers to Ascot. The picture shows what is probably the first Information Bureau of Windsor in the foreground.

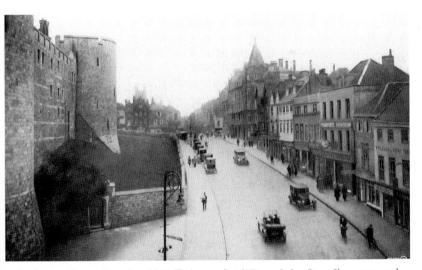

Looking up Thames Street from Mr Tull's shop roof, with Dyson & Son Piano Showrooms, and some early motor cabs on the taxi rank. The high wall around the Castle lawns has been removed.

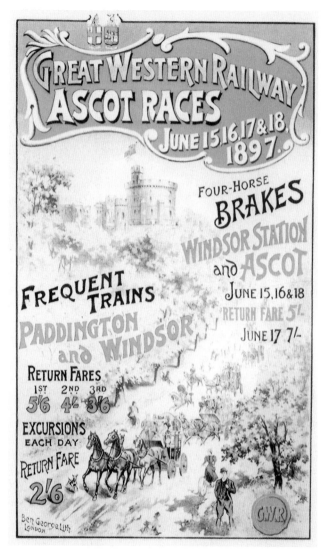

Royal Ascot Week takes place on land owned by the monarch and was begun in 1711 by Queen Anne, who was a keen horse woman, and presented the Queen's Plate and a prize of 10 guineas for the winner. Although Queen Anne had established the course, it was not until George IV's reign that the Royal procession preceded the racing.

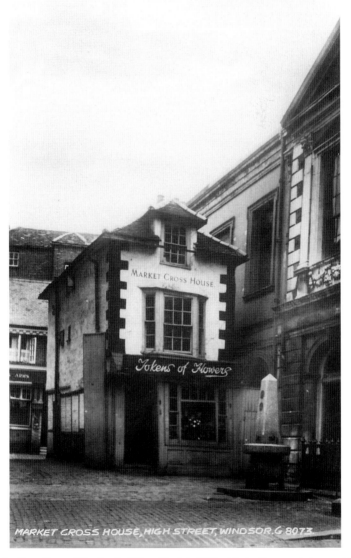

MARKET CROSS HOUSE, HIGH STREET, WINDSOR. G.8073

Market Cross House, (The Crooked House) built in 1687, with the Carpenter's Arms public house in the background.

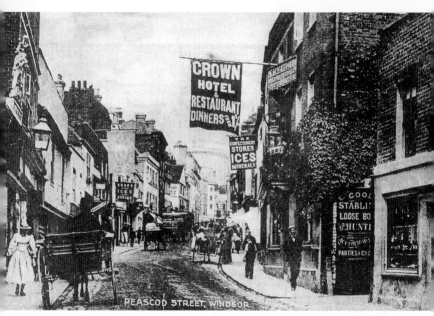

PEASCOD STREET, WINDSOR

Peascod Street may be a haven for tourists, but its bustling confines are pure hell to Windsorians struggling with the Saturday morning shopping. Its claustrophobia hardly bears comparison with the scene above, c. 1905. The general vista with the Castle providing a dominating background remains, however, the same. It is only the detail that makes such a difference, like the way the carriages amble along in both directions and the curious habit people seem to have of actually strolling along the street. There's the Crown Hotel's boast – dinners from one shilling – and the stables which can accommodate parties and cycles. And there can't be all that many butchers selling ice cream these days.

Opposite: The Silver Jubilee of King George and Queen Mary and the procession in the town. The King was in poor health and was represented by Prince Henry of Gloucester. This picture was taken in Peascod Street, outside the Duke of Cambridge public house, with William Creak's store in the background, now the General Post Office.

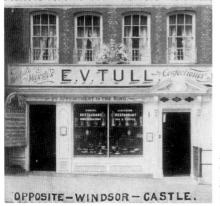

As well as catering, Mr Tull created chocolate confections and speciality cakes and displayed them in his shop window in Thames Street. His twin sons also ran the bakery at the top of Peascod Street.

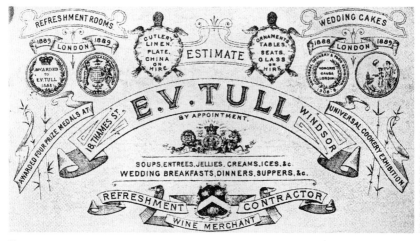

Harding's Garage, 25 St Leonard's Road. Mr Harding and his mechanics are outside the workshops where cars were sold and repaired. Pictured below is a trade advertisement for E. Sargeant & Son, also of St Leonard's Road, Windsor.

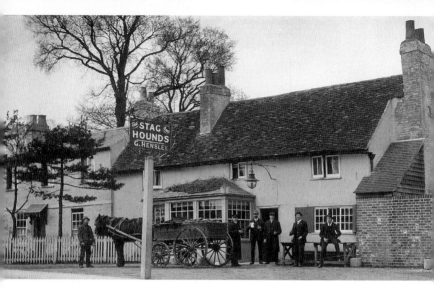

Patrons enjoying refreshment at the Stag and Hounds, in the 1920s.

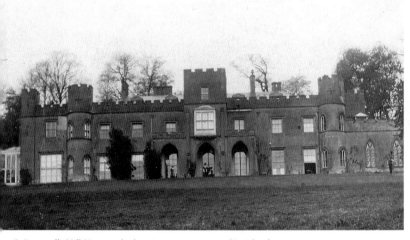

St Leonard's Hill House, which now comprises part of Legoland.

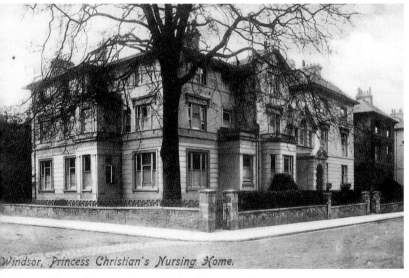

Windsor, Princess Christian's Nursing Home.

Princess Christian's Nursing Home, which still operates today.

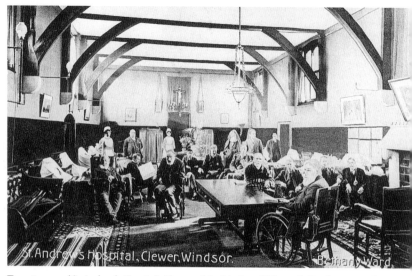

Two pictures of St Andrew's Hospital, Clewer, of the Men's and Women's Wards. One card is dated 14 January 1913.

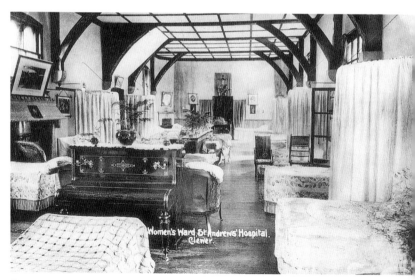

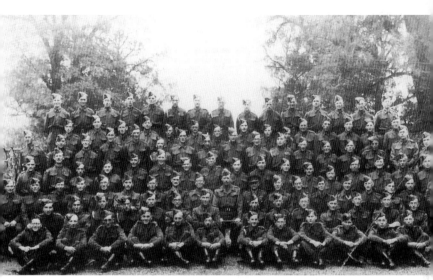

Windsor's Home Guard. In May 1940, Anthony Eden called on men aged between 17 and 65 who were not engaged in military service (because of their age, infirmity or reserved occupation) to join a Local Defence Volunteer Force. By July, when the name of the force was changed to the Home Guard, recruitment had to be suspended because over 1,300,000 men had enrolled. The Home Guard was Britains' part-time army. Each member received a personal certificate from His Majesty King George VI thanking him for giving generously of his time and powers to make himself ready for the defence of the country by force of arms and with his life if need be, and showing the length of service.

E R

I WISH TO MARK, BY THIS PERSONAL MESSAGE, my appreciation of the service you have rendered to your Country in 1939.

In the early days of the War you opened your door to strangers who were in need of shelter, & offered to share your home with them.

I know that to this unselfish task you have sacrificed much of your own comfort, & that it could not have been achieved without the loyal co-operation of all in your household.

By your sympathy you have earned the gratitude of those to whom you have shown hospitality, & by your readiness to serve you have helped the State in a work of great value.

Elizabeth R

Most families in Windsor took in evacuees during the Second World War. Pictured above is a message of thanks from the Queen to all those people who gave hospitality to evacuees. Below are the two girls who stayed with Nancy Stiles of Grove Road: Betty Solomons from Bow and Betty Cowan from Fulham, taken in the Long Walk. The author is in the middle.

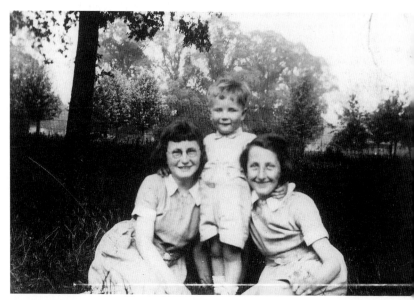

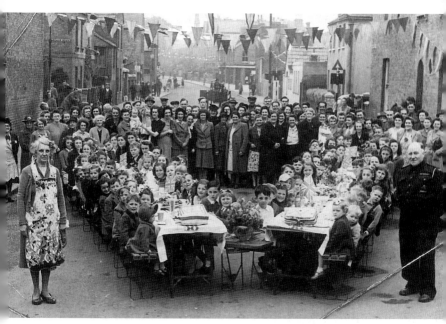

Victory celebrations; the inhabitants and younger residents of Arthur Road celebrate in their own special way in May 1945. Among the individuals who can be identified in this picture are: Mrs Hughes and her son Stewart, Mrs Wells, Mrs Peachy, Mrs Mumford, Mrs Dobson, Mr Carnie, a number of the Last family, George Camm, Harold Shrimpton, with Mrs Clatworthy and Joe Brooks, A.R.P. Warden, the organisers in the foreground. Don't forget Moore's Vale Road bus stops in the rear.

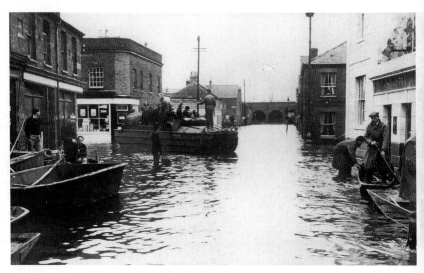

The junction of Oxford Road and Alma Road, with the Clarence Hotel (now the Copper Horse) and Hoggs the grocer on the other corner, as well as the GWR viaduct and the Windsorian garage in the background.

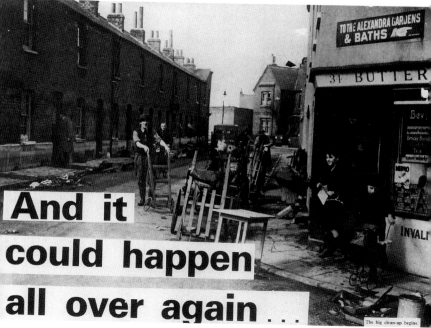

And it could happen all over again...

The big clean-up begins.

Grosvenor Place, cleaning up with Mr Dunn, the assessor of the flood damage, Tim Bashford the cyclist, Mr Butterworth with his wobbly barrow and Alan Brown with his sister Margaret. Note, on the left, the sign of Charlie Vass the chimney sweep and the directions to Alexandra Gardens and the Baths.

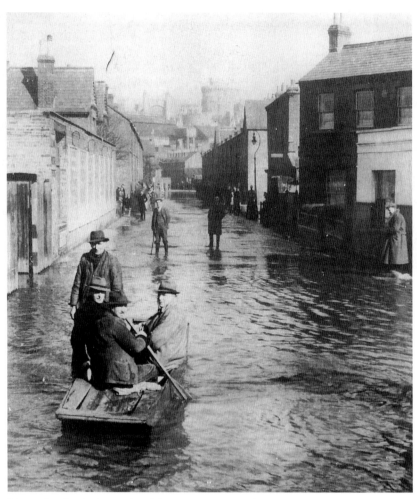

The receding floods of 1947. The Globe corner, Oxford Road, with Bill Pomfret the local greengrocer and other locals looking on. All have been demolished and replaced by Ward Royal.

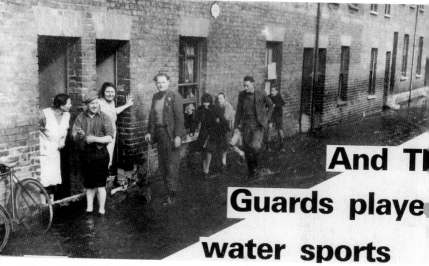

And T[h]

Guards playe[d]

water sports

Residents of Arthur Road clearing up, with Fred Hamblin (a bus driver with London Transport) and Harry Gray.

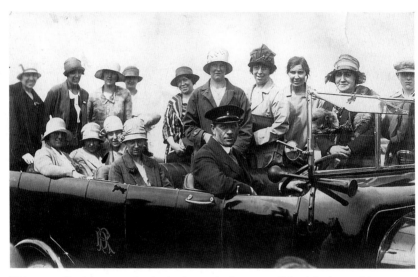

Waitresses at Royal Ascot, catering for the thousands of race goers. Behind the driver is Mrs Butler of Oxford Road and just behind her is the author's grandmother, Eva Stiles.

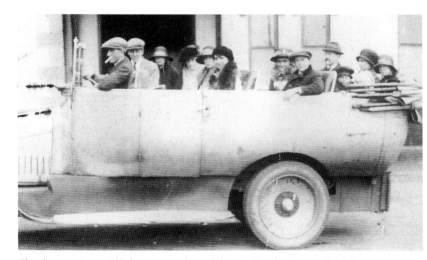

Charabanc outings quickly became popular and this is believed to be one of the first Windsorian coaches.

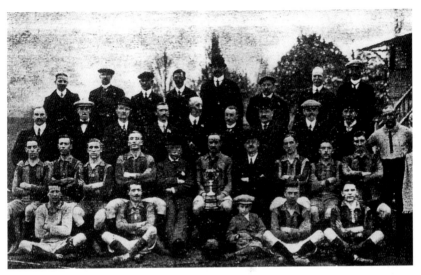

Berks & Bucks Cup Winners 1910/11.

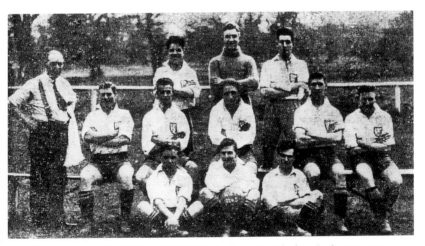

In the 1st round of the F.A. Cup, 1924/5, Windsor lost 2-4 to Charlton. In the team were:
P. Finch, Len Fardell, Albert Float, Dick Shuttle, Tory Norris, F. Dawson, W. Gee, S. Morris,
Billy Coward, H. Hewitt and Bill Tatton.

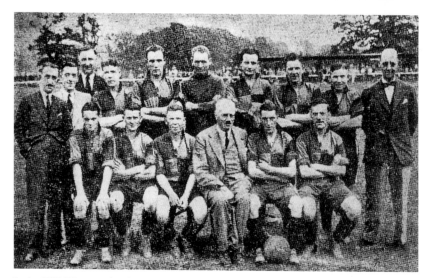

In the 1938/39 season the players were: C. Wilkins, C. Ralph, P. Powell (Capt), H. James, C. Nicholls, C. Clements. Mr Jim Ottrey (Builder Chairman). Front row: E. Woodford, J. Evans, J. Gulliford, Mr Crisp (President), F. Bowyer and J. Maddocks.

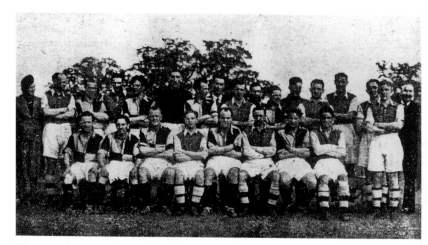

Windsor and Eton vs Arsenal, 2 May 1949. Windsor's team: Graham Linsey, J. Beach, Ronnie Gadson, G. Cox, Dave Hives, E. (Boy) Newhouse, Cliff and Ronnie Williams, Joe Griffiths, J. (Snapper) Lawrence and Stevie Mills. Arsenal's team: Dunkley, Chennall, Ollershaw, Babes, Fields, Arpino. Holland, Griffiths, Duffey, Grimshaw and Davis. Windsor lost 3-1.

Six

Military

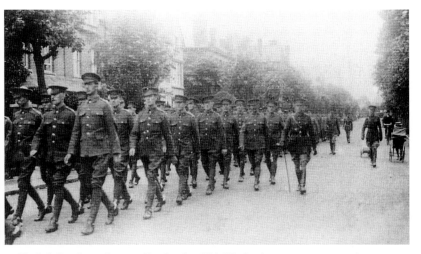

The Life Guards marching up Alma Road, *c.* 1914. Windsor being a garrison town, the army was very much part of the life of the residents of Windsor, with many soldiers marrying local girls and setting up home in the town.

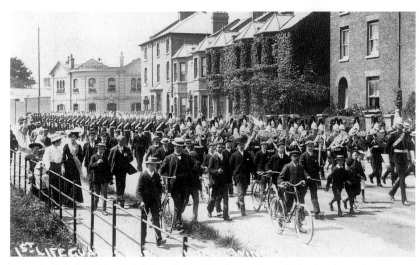

Postcard of July 1905. The 1st Life Guards leave Combermere Barracks for church parade at the Garrison Church of Holy Trinity. Men and children still like to walk beside the band when marching through the streets. The large house on the right was Len Kirkland's lodging house and transport cafe.

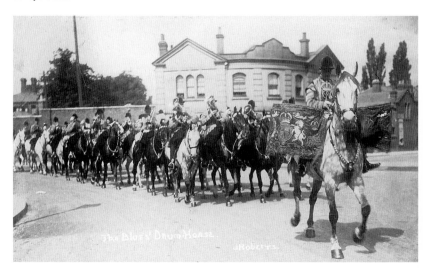

Postcard of August 1913 of the mounted band of the Blues, led by the Drum Horse, in front of the Lord Raglan public house.

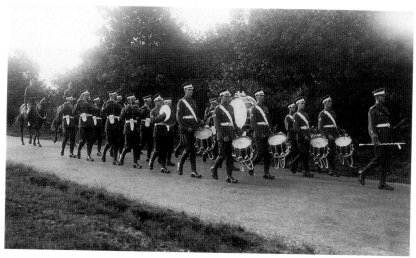

The Band of the Coldstream Guards above, leading a Battalion of Scots Guards, below, with mounted officers at Smiths Lawn Camp, *c.* 1914.

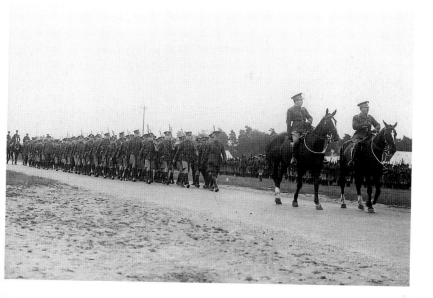

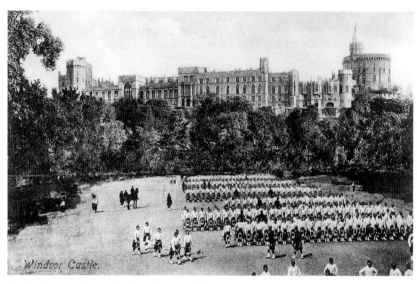

The Gurkhas parading in the Home Park, *c.* 1903.

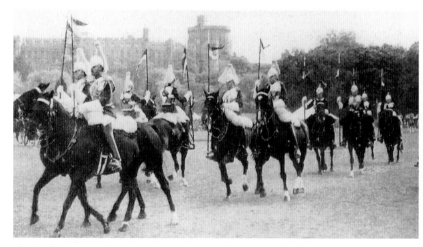

The five-day Royal Windsor Horse Show takes place in the Home Park. The show originated in 1943 as a fund raiser for the Wings for Victory Campaign and has grown in importance every year. The events of the show take place in various rings and cross-country courses. Two of the high spots of the show are the Musical Ride by the Household Cavalry and the massed bands of the Foot Guard Regiments.

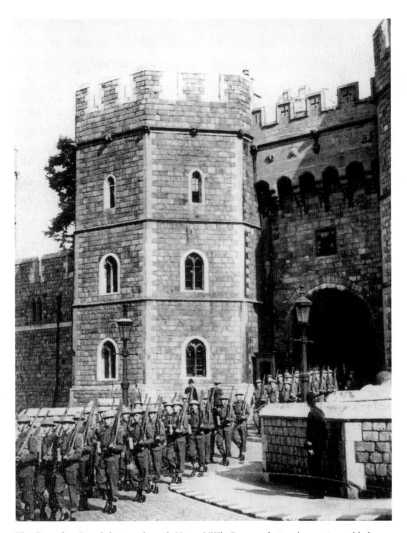

The Grenadier Guards leaving through Henry VIII's Gateway during the war in steel helmets and battledress. At that time, residents gained admittance after dark by password. The oldest of the five regiments of Foot Guards is the Grenadier Guards, raised in 1656 by Charles II from his followers in Bruges while he waited to be restored to the throne. Originally called the Royal Regiment of Guards, their title was changed in 1815 to the First or Grenadier of Foot Guards. On parade in ceremonial dress they are identified by their evenly spaced tunic buttons and the white plume in their bearskins.

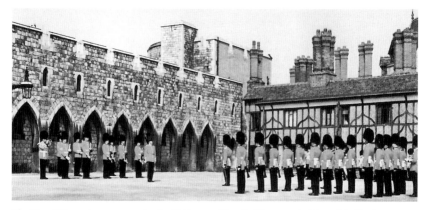

The Guard Mounting ceremony by the Coldstream Guards. The second oldest of the Regiments of Foot Guards was raised in 1659, on Cromwell's order as Colonel Monck's Regiment of Foot, to form part of the New Model Army. Their name comes from the small town on the Scottish border where the Regiment was first quartered. On parade their distinguishing features are the red plumes on the right of their bearskins and tunic buttons grouped in threes.

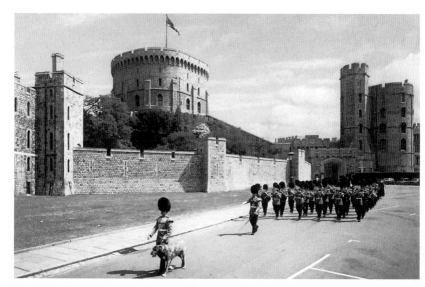

The band of the Irish Guards, with their Irish wolfhound mascot, Shaun, marching down Castle Hill. Queen Victoria formed the Irish Guards in 1900 as a mark of recognition for the courage of her Irish troops in the Boer War in South Africa. Irish Guards are distinguished by their tunic buttons in groups of four and either the blue plume of St Patrick's, or bristle, according to rank.

Schools and Pageants

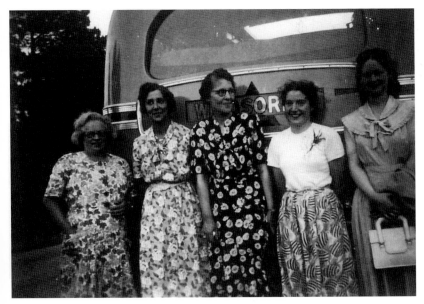

Alexandra Road Infant's School, *c.* 1949, with the Headmistress Miss Akery and her staff, with a Windsorian coach in the background.

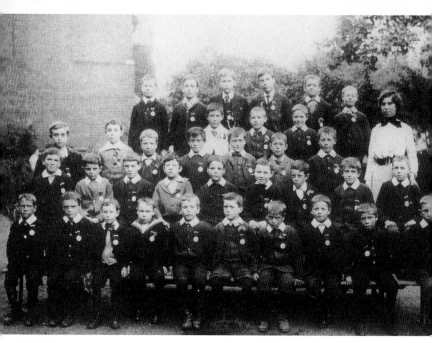

Pupils of the Royal Free School on Batchelors Acre, each boy wearing his Coronation Medal commemorating King Edward's Coronation of 1902. The schoolmistress is possibly Miss E. Lewis, who taught for many years until 1948.

Coronation celebrations. Inhabitants and children of Grosvenor Place and Denmark Street celebrate in their own special way in May 1937.

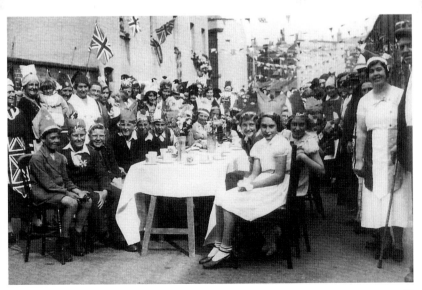

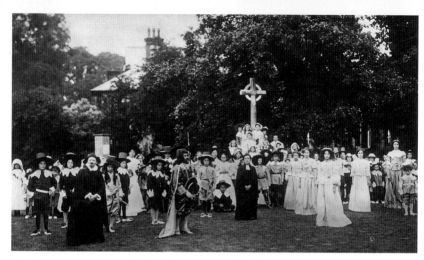

Historic events re-enacted by local school children at Windsor Fair in the Clarence Crescent Park, 1915.

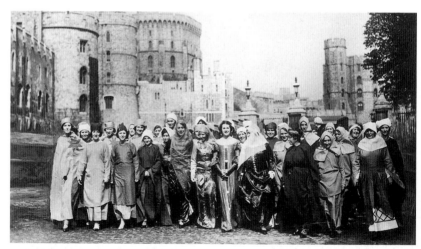

Local school children and dramatic societies re-enact the story of King John signing the Magna Carta, 1934.

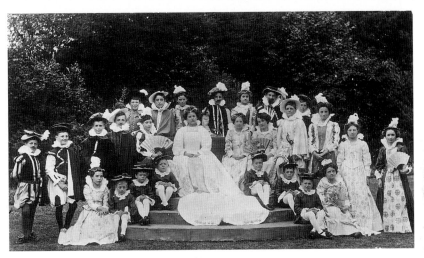

Dramatic portrayal of Queen Elizabeth and her Court.

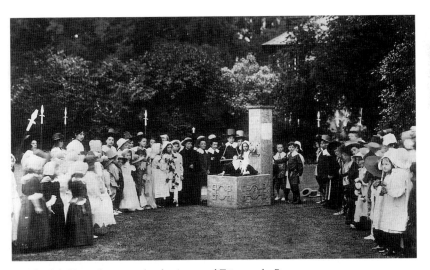

School children take part in the play Asson and Trieste at the Pump.

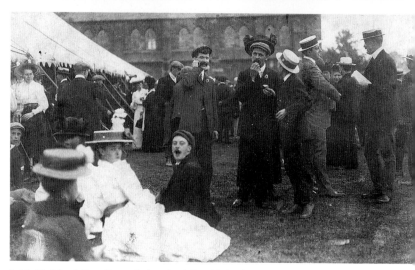

St Mark's School Open Day with the school chapel behind, after Imperial Service College finally amalgamated with Haileybury School. The buildings were used during the war by the A.T.S. then after by the Life and Royal Horse Guards as the overflow from Combermere Barracks.

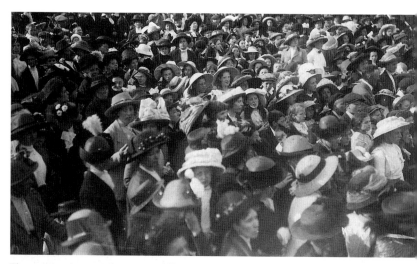

The correspondence on the rear is as follows: 'I sent you this P.C. of Empire Day, 23 May 1913. I wonder if you can see me in the crowd?'

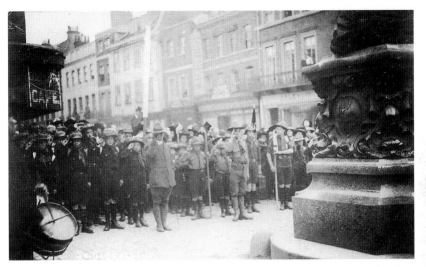

St George's Day Parade Boy Scouts and Boys Brigade assembled in the High Street, April 1913; in the background are Caleys and the White Hart Hotel.

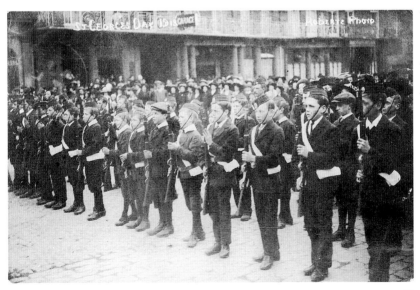

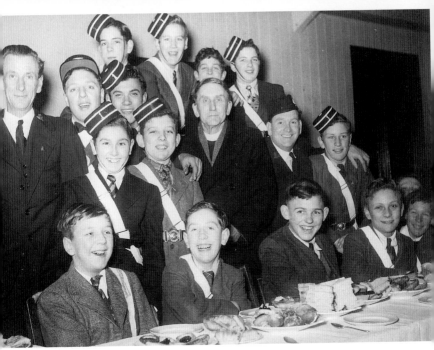

Windsor's Boys Brigade, Christmas party, 1951. From left to right: Mr Andrews, Mick Martin, David Shiletto, Fred Williams, Dave Middleton, Ken Baille, Eric Davies, Ian Baille, Keith Weller, Mr Coates (Minister), Mr Lawson, Ray Castle, Mike Stiles, Dave Green, Jimmy Rioch, Angus Forsyth and Ginger Thompson.

Eight

Churches

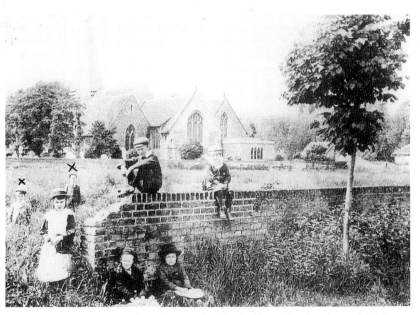

The Parish Church of St Andrew, Clewer, is the oldest building in Windsor. It is probably Saxon and certainly contains elements of the Norman style.

Be thou faithful unto Death and I will give thee a crown of Life.

Vincent Bernard Patrick Stiles

Baptized August 4 1889
at Clewer S. Stephen

Confirmed March 20 1903, at Clewer S. Stephen
by the Bishop of Reading

First Communion Palm Sunday 1903
at Clewer S. Stephen.

Signed Ernest A. Thorne.

A DAILY PRAYER

Almighty and Everliving GOD,
defend me, Thy servant, with Thy
Heavenly Grace, that I may continue
Thine for ever; and daily increase in Thy
Holy Spirit more and more, until I come unto
Thine Everlasting Kingdom. Through our
Lord Jesus Christ.

Amen.

No 109.

S.P.C.K.

Johnson, Riddle, Couchman & Co London

The Parish of Clewer St Stephens, was formed in 1872 and the church was consecrated in 1874.

Right: Parish Church of John the Baptist, High Street, c. 1900, with the hackney carriage where the horse's food would be kept while waiting for customers and while resting between journeys. The shop on the right has long been removed and there was no War Memorial until the 1920s.

Below: All Saints Church, Francis Road.

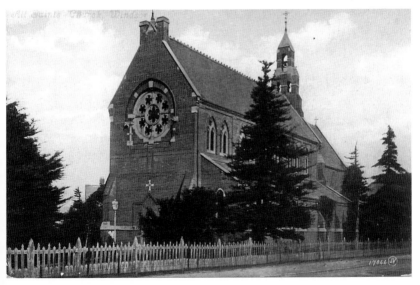

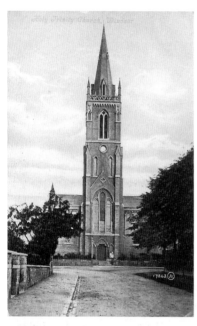

The Life and Horse Guards Garrison Church of
Holy Trinity. One card is dated 3 December 1906.

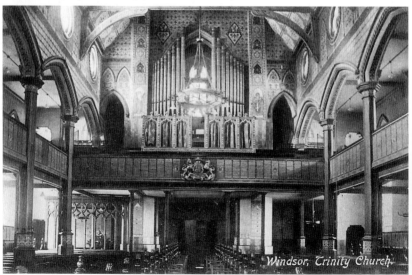

Nine

Eton and College

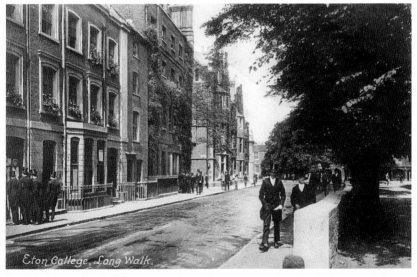

Eton College, Long Walk.

With the opening of the Windsor relief road and the closing of Windsor Bridge to through traffic in the mid 1960s, Eton returned to its sleepy hollow once again after being the main road to Slough with double decker buses, large lorries and many hundreds of cyclists travelling there to and from their places of work.

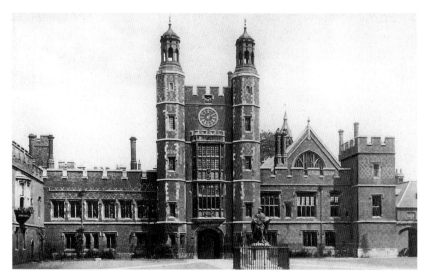

The Quadrangle, Eton College.

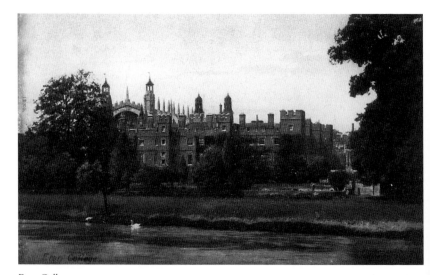

Eton College.

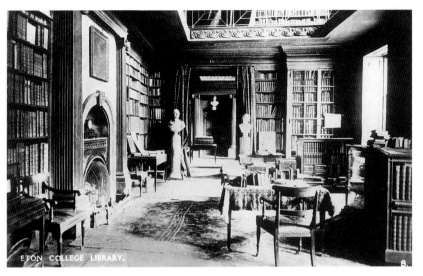

Eton College Library.

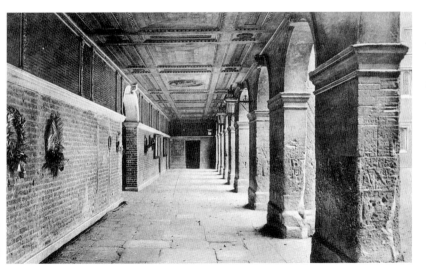

Eton College Cloisters.

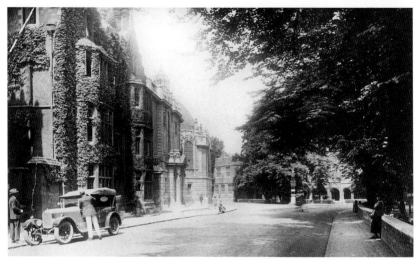

Eton College, Long Walk, from a postcard dated October 1926.

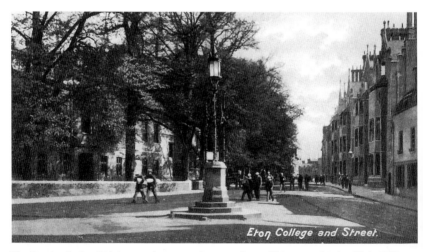

The Burning Bush, which has now been moved to a new home. This postcard is dated July 1905 with the correspondence on the rear saying: 'I am having a delightfull time shall not want to come back this is the street I am staying in.'

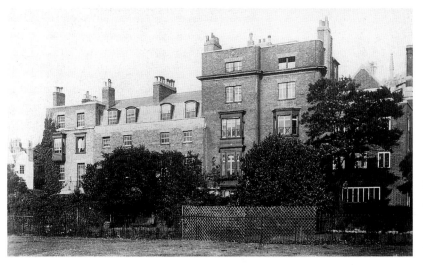

Baldwin's Bec., Eton College.

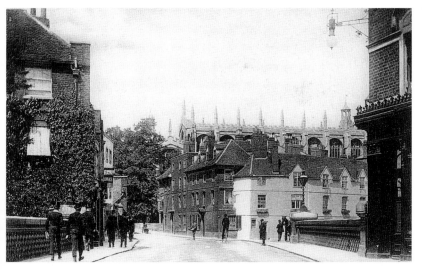

Eton College from Barnspool Bridge.

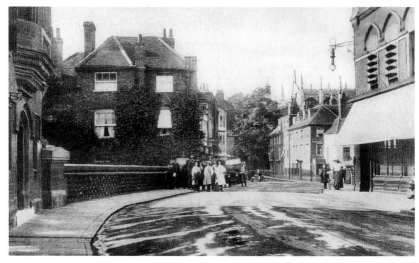

Barnspool Bridge, 1920s.

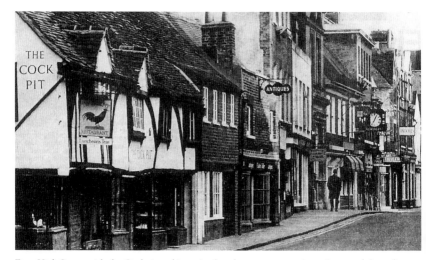

Eton High Street, with the Cockpit and its pair of stocks, numerous antique shops and the police station and College Arms public house.

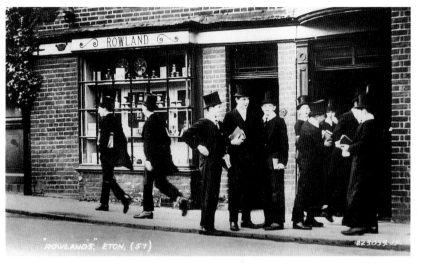

College Boys outside Rowland's tuck shop and snack bar, 1950s.

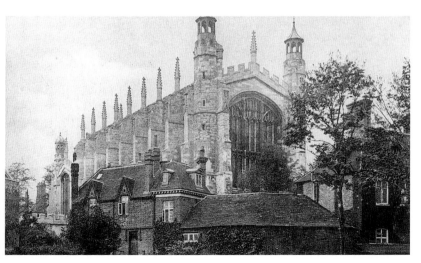

Postcard of 31 December 1904, used as a New Year's card with the writing on the back saying:
'Wishing You A Happy New Year.'

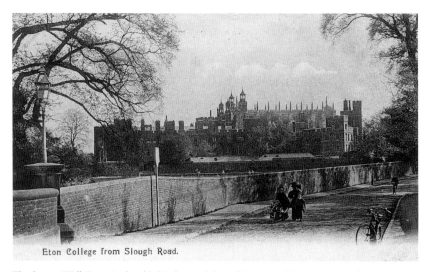

Eton College from Slough Road.

The famous Wall Game is played behind part of the wall shown in this picture, every St Andrew's Day. The post mark is 1906.

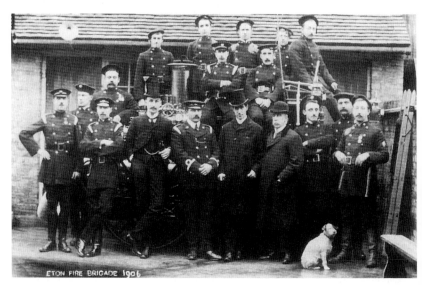

Eton Fire Brigade, 1906.

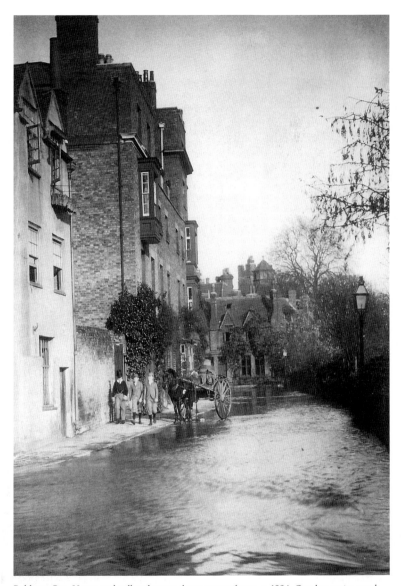

Baldwins Bec. House and college boys in their grey uniforms, *c.* 1894. One has a nice watch-chain dangling from his waist-coat.

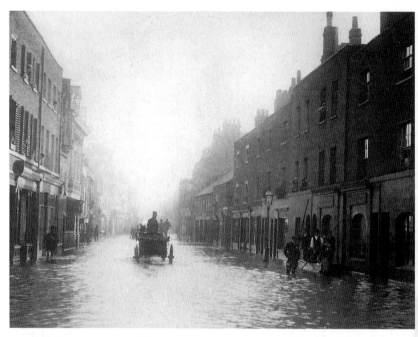

Eton High Street, *c.* 1894. Note the driver of the hackney carriage wearing a top-hat.

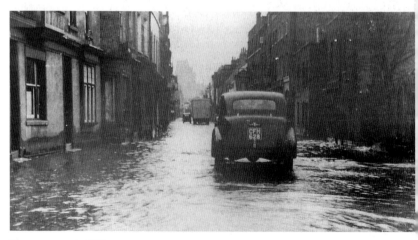

The same scene in 1947.

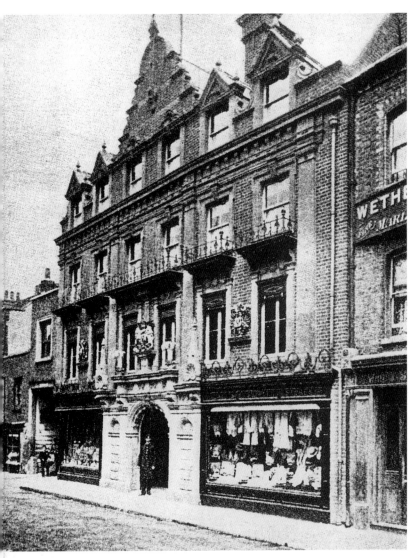

Herbert's Stores as Harrods, Army & Navy and Civil Services Stores all rolled into one, proud of their Royal patronages; there were twenty-four departments as well as a refreshment room. To the left are the premises of Putnam the upholsterers, and to the right is Wetherhead's of Marlow and The Three Tuns Inn.

ETON COLLEGE,

WINDSOR, *Mids Half* 190 8

J. Stopford Sackville Esq

Dr. to MAT WRIGHT.

⁘ Cricket . Outfitter, ⁘

AND

PROFESSIONAL CRICKETER TO ETON COLLEGE.

| 1908 | | | | |
|------|------------------|---|---|
| June 4. | Hire of 6 chairs | | 6 | 0 |

College Boy's Term Accounts, 1908.

UNDER ROYAL PATRONAGE.

19. High Street,

Eton, July 1908

L. C Stopford Sackville Esq

By Appointment to
ETON COLLEGE

FLOREAT ETONA

To H. Jefferies,

Hair Dresser & Perfumer.

ATHLETIC OUTFITTER &c.

Mar 27	Hair Cut & Shampoo	1	.
May 29	" "	1	6
June 4	" " & Shampoo	1	.
22	Shampoo		6
25	Hair Cut & Shampoo	1	.
		4	